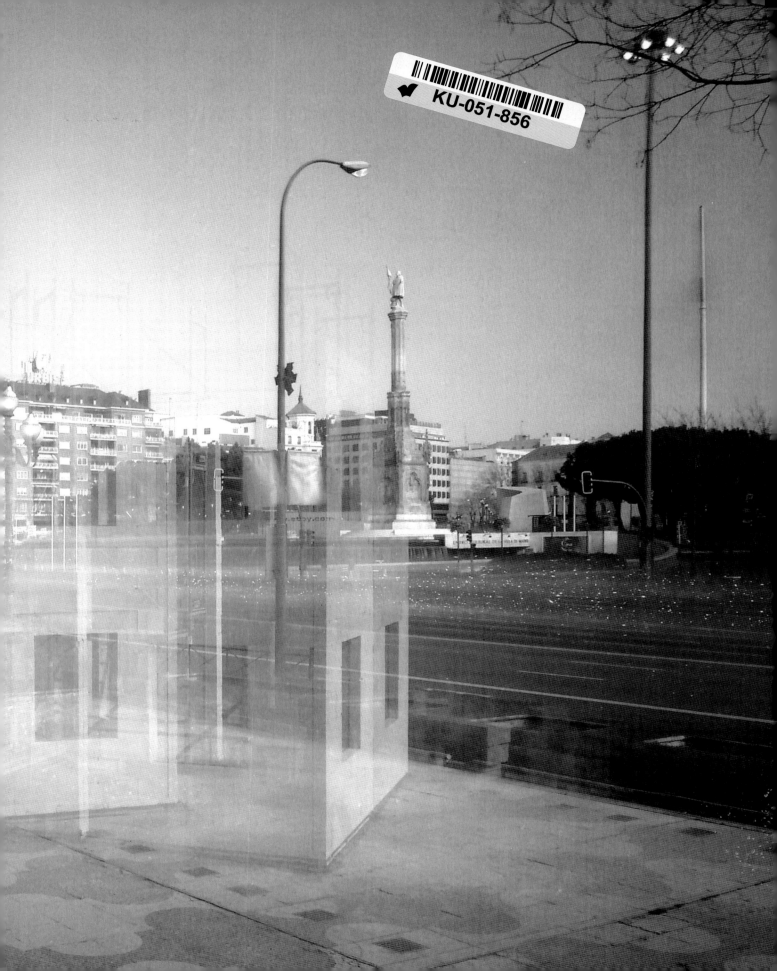

house-
projects

WOLFGA

h
pr

ANG WEILEDER

house-
ojects

Edited by Florian Matzner
and Nigel Prince

IKON

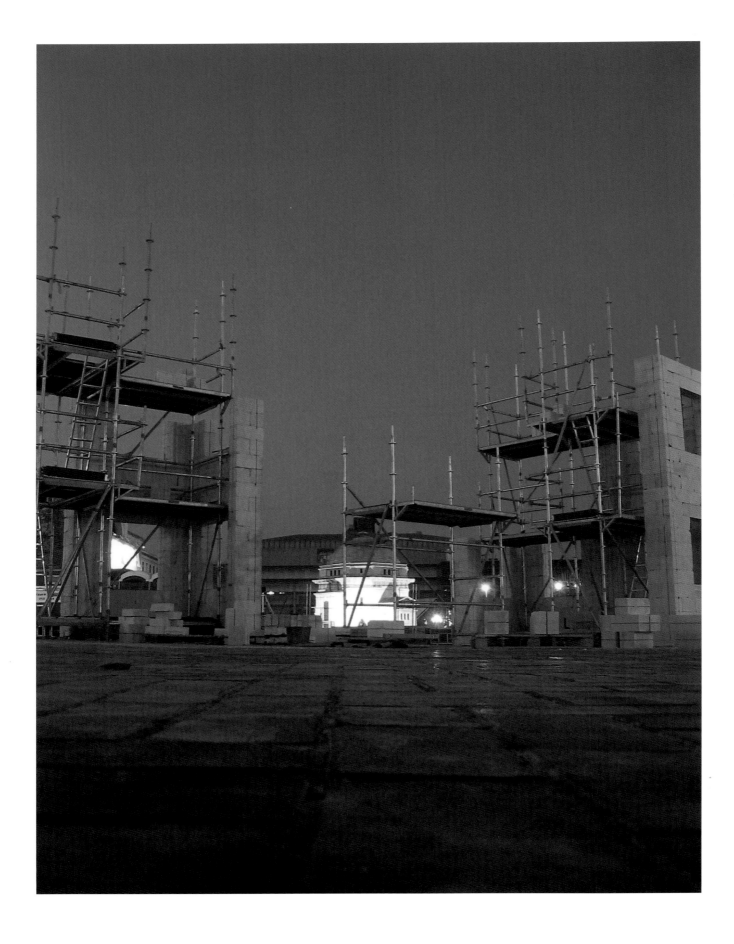

FOREWORD

House-birmingham by Wolfgang Weileder was a highlight in Ikon's recent artistic programme. Off-site, located in Birmingham's Centenary Square, it was seen by hundreds of thousands of people, a potentially endless process of construction and deconstruction. *House-birmingham* certainly was not a finished self-contained work of art; it was a process, an ongoing cooperation between participants, an engaging conversation between the artist and his audiences. It disappeared as it appeared, out of nowhere, without a trace, at once monumental and fugitive.

House-birmingham was a complex response to Birmingham, making specific reference to the ubiquity of terraced houses in this city. Its basic module was an archetype of this domestic architecture, waltzing around in a public space surrounded by various civic structures against a high-rise sky-line. The urban fabric around the work itself continues to be in a constant state of flux, catalysed through concerted efforts by the local authority to regenerate districts that have been lying fallow or neglected. Building sites, portacabins, pneumatic drills, cranes and hard-hats are everywhere, and if not always stylish, at least it can be said that Birmingham is assertive in its desire for change. Weileder's work thus epitomises this place.

The cyclical format of *house-birmingham* was matched by a recycling of materials, and an ecological aesthetic. The use of a new kind of clip-fit brick, for example, could not have been more appropriate for an artist who is aware of a bigger world picture in which basic resources are increasingly acknowledged to be limited. The involvement of building apprentices was very neat conceptually, and, at the same time, constructive in more ways than one. Such aspects of the project signified its versatility and inclusiveness. In this vein, we take this opportunity to acknowledge the generosity of Paul Webster and RBAU Contractors, Layher and Acorn Scaffolding, Ronald van Zijl and Eurobloque, Shaun Catterall, Terry Carver and Bill Clarke of CITB/National Construction College, Taylor Woodrow, Terry Prayne and all apprentices of South Birmingham College, Intracamion, Munich, and the City Centre Management and Health and Safety teams of Birmingham City Council.

Above, all thanks to the artist.

JONATHAN WATKINS
DIRECTOR

VORWORT

House-birmingham von Wolfgang Weileder stellte ein Glanzlicht im jüngsten Programm der Ikon Galerie dar. Angesiedelt auf dem Centenary Square im Herzen von Birmingham, sahen es hunderttausende von Menschen: einen potentiell endlosen Vorgang von Konstruktion und Dekonstruktion. *House-birmingham* war kein fertiges, in sich geschlossenes Kunstwerk; es war vielmehr ein Prozess, eine anhaltende Zusammenarbeit aller Teilnehmer, eine anregende Unterhaltung zwischen dem Künstler und seinem Publikum. Es verschwand, wie es entstand, aus dem Nichts, ohne jede Spur, monumental und flüchtig zugleich.

House-birmingham stellt eine vielschichtige Reaktion auf Birmingham dar, indem es sich bewusst auf die Allgegenwart von Reihenhäusern in dieser Stadt bezog. Bestimmendes Strukturelement der Arbeit war der Archetyp dieser Wohnarchitektur, und Weileder ließ ihn auf diesem öffentlichen Platz Walzer tanzen, umringt von verschiedenen städtischen Gebäuden und vor einer Skyline von Hochhäusern. Die urbane Landschaft, in die das Kunstwerk eingebettet war, ist nach wie vor in ständigem Wandel begriffen, einem Wandel, den konzertierte Aktionen der öffentlichen Hand katalysieren. Sie dienen dem Zweck, verödende oder vernachlässigte Bezirke umzugestalten. Baustellen, Baustellencontainer, Pressluftbohrer, Kräne und Schutzhelme, wohin man auch blickt, und wenn Birmingham auch nicht immer Eleganz beweist, so ist es der Stadt mit ihrem Verlangen nach Wandel doch unbestreitbar Ernst. Weileders Arbeit liefert uns das perfekte Modell dafür.

Die zyklische Ausführung von *house-birmingham* passte gut zum Recycling der verwendeten Materialien und zu seiner ökologischen Ästhetik. Die Verwendung einer neuen Art von zusammensteckbaren Steinen z. B. hätte kaum angemessener sein können für einen Künstler, in dessen Weltbild die zunehmend anerkannte Tatsache begrenzter Rohstoffe fest verankert ist. Die Heranziehung von Maurerlehrlingen war konzeptuell ebenso geschickt wie konstruktiv, und zwar in vielfacher Hinsicht. Solche Aspekte des Projekts unterstreichen seine Vielseitigkeit und Integrationskraft. In diesem Sinne möchten wir Paul Webster und R.BAU Contractors für ihre Großzügigkeit danken, des weiteren Layher and Acorn Scaffolding, Ronald van Zijl und Eurobloque, Shaun Catterall, Terry Carver und Bill Clarke vom NITB/National Construction College, Taylor Woodrow, Terry Prayne und allen Lehrlingen vom South Birmingham College, Intracamion in München, den Teams vom City Centre Management sowie von Health and Safety der Stadtverwaltung von Birmingham.

Vor allem aber gilt unser Dank dem Künstler.

JONATHAN WATKINS
DIREKTOR

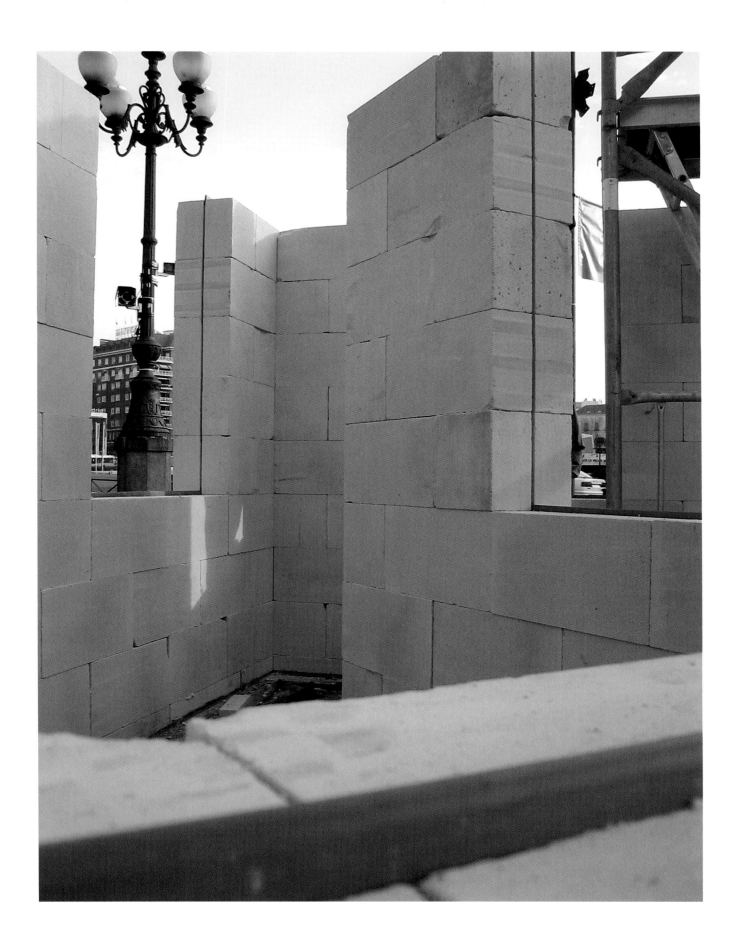

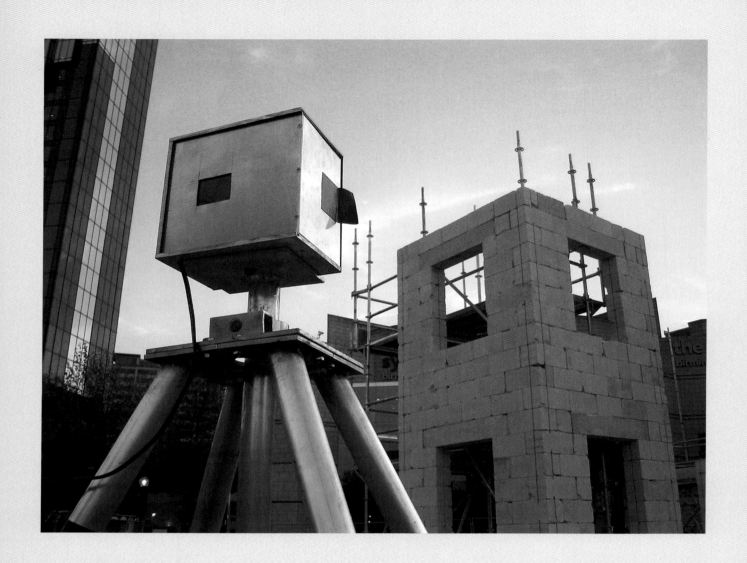

Florian Matzner

ART – CITY – ARCHITECTURE

"Time is fast – Space is slow", Vito Acconci once stated, and went on to elaborate: "Space is an attempt to place time, and understand time."[1] With this simple yet subtle statement, the grand old man of Public Art aptly summed up the central problem inherent in the relationship between a city and its inhabitants, between architecture and the flâneur, between art and its audience. Urban space as a user interface of human communication, indeed, as an interface between space and time, also defines Wolfgang Weileder's central field of artistic activity.

The idea that art, architecture, and public discourse are fundamentally different modes of human behaviour is a bourgeois concept rooted in the 18th and 19th centuries – based, erroneously, on the idea of art as autonomous and essentially divorced from other aesthetic and functional media. Not until the advent of the teachings of the Bauhaus and the ideas introduced by constructivism have we become aware of a new dimension of co-operation and dialogue between the fine arts and architecture – a dimension nowhere more evident than in unprotected urban space. As Daniel Buren recently stated: "In my view, one of the advantages of public space lies precisely in its capacity to destroy the autonomy falsely attributed to the work displayed within it."[2]

And yet: Public Art – as American English aptly calls it – is precisely not subject to the condition of reception that applies to art displayed in the refined environs of our museums for the appreciation of a specialised audience of connoisseurs. Rather, Public Art consciously exposes itself to the

KUNST – STADT – ARCHITEKTUR

»Time is fast – Space is slow« hat Vito Acconci einmal gesagt, und weiter: »Der Raum ist ein Versuch, die Zeit zu orten und zu verstehen.«[1] Mit dieser ebenso einfachen wie subtilen Aussage hat der amerikanische Altmeister der Public Art jedoch das zentrale Problem des Verhältnisses zwischen Stadt und seiner Bewohner, zwischen Architektur und Flaneur, zwischen Kunst und Rezipient beschrieben. Der Stadtraum als Benutzeroberfläche menschlicher Kommunikation, eben als Schnittstelle zwischen Raum und Zeit, ist auch das zentrale Aktionsfeld von Wolfgang Weileder.

Und weiter: Die Vorstellung, Kunst und Architektur und Öffentlichkeit seien grundsätzlich unterschiedliche Verhaltensmuster, ist eine bürgerliche Vorstellung des 18. und. 19. Jahrhunderts, in der man fälschlicherweise von der Idee der Autonomie der Kunst gegenüber den anderen ästhetischen und funktionalen Medien ausging. Erst seit den Lehren des Bauhauses und den Ideen der Konstruktivisten gibt es eine neue Dimension der Kooperation und des Dialogs zwischen den bildenden und den bauenden Künsten – und dies gerade und vor allem im ungeschützten Stadtraum, denn – so konstatierte Daniel Buren vor einigen Jahren – »in meinen Augen liegt gerade einer der Vorzüge des öffentlichen Raums darin, den Irrtum von der Autonomie des in ihm gezeigten Werkes zu zerstören.«[2] Und trotzdem: Kunst im öffentlichen Raum – für die der amerikanische Sprachgebrauch den treffenderen Ausdruck der Public Art bereithält – unterliegt eben nicht den Rezeptionsbedingungen eines spezialisierten Kunstpublikums in den heiligen Hallen eines Museums-

accidental passer-by: to the cab-driver as much as to the bank manager, to the child on its way to school, the house-wife, and the unemployed person. For this reason, Public Art needs to employ different strategies and arguments to ensure that it is seen as art rather than be misunderstood as a merely temporary and accidental construction.[3] Herein also lies Public Art's greatest opportunity – to quote (somewhat playfully) Daniel Buren again: "If you are courageous and foolish enough to show others what you have made, and show it publicly at that, you inevitably invite comment and analysis, praise and criticism. Incidentally, the term 'Public Art' itself suggests a certain element of disdain; after all, we sometimes dub prostitutes 'public ladies'."[4]

For the past five years or so, Wolfgang Weileder's artistic concepts have engaged with the relationship between art and architecture, and indeed with the relationship between aesthetics and functionality. In *Shelters* (2000), Weileder designed three bus shelters orientated to such a degree that people could no longer enter them – their ostensible functionality was subordinated to an aesthetic dimension, the user suddenly relegated to the position of viewer. The motif of transforming an outside space into an enclosed interior recurs in Weileder's performance entitled *cage*, also made in 2000. Three actors stand on a small platform facing away from one another; the first begins to explain the meaning of the term "cage" to the audience; the second picks up on a word from the first actor's definition and proceeds to explain this new word; the third picks up on a word or catch-phrase from the second actor's speech and begins to explain its meaning… and so on and so forth. An endless cycle of explanation and commentary, definition and opinion is set in

cage, 2000
Galerie der Künstler, Munich
(with Karin Brandstätter,
Roland Trescher and Andreas Wolf)

tempels, sondern setzt sich bewusst dem zufälligen Passanten aus: dem Taxifahrer ebenso wie dem Bankmanager, dem Schulkind ebenso wie der Hausfrau und dem Arbeitslosen. Deshalb muss die öffentliche Kunst hier anders argumentieren, andere Strategien einsetzen, um eben als Kunst und nicht als kurzzeitige Baumaßnahme missverstanden zu werden.[3] Andererseits liegt darin ihre große Chance, denn – um noch einmal schmunzelnd Daniel Buren zu zitieren – »wer den Mut und Leichtsinn besitzt, anderen zu zeigen, was er gemacht hat, und das auch noch öffentlich, der lädt nun einmal zu Analysen und Kommentaren ein, zu Lob und Kritik. In der Bezeichnung ›öffentliche Kunst‹ selbst liegt übrigens auch eine gewisse Verachtung, schließlich werden Prostituierte bisweilen ›öffentliche Damen‹ genannt.«[4]

Bereits seit mehr als fünf Jahren beschäftigt sich Wolfgang Weileder in seinen künstlerischen Konzepten mit dem Verhältnis von Architektur und Kunst und weiterführend mit dem Verhältnis von Ästhetik und Funktionalität. Mit »shelters« von 2000 hat er drei Wartehäuschen konzipiert, die so ineinander verschachtelt sind, dass sie nicht begehbar sind – die scheinbare Funktionalität unterliegt der ästhetischen Dimension, der Benutzer wird unversehens zum Betrachter ›degradiert‹. Das Motiv der Umformulierung eines Außenraumes zu einem geschlossenen Innenraum hat Weileder auch zum Thema einer ebenfalls 2000 konzipierten Performance mit dem Titel »cage« gemacht: Auf einem kleinen Podest stehen drei Schauspieler mit dem Rücken zueinander, der erste Akteur beginnt, dem Publikum den Begriff »cage« zu erklären, der zweite Schauspieler übernimmt einen Begriff aus dem Bericht des ersten und erklärt diesen, der dritte wiederum greift sich aus der

motion, so that both the course and the eventual end of the performance, that is its thematic as well as its temporal extension, become incalculable and move beyond the artist's control. Both works address the relationship between time and space, reality and virtuality, as analysed by Vito Acconci. Viewed in this light, both works can be read as preliminary studies to the *house-projects* Weileder has been realising since 2002.

During the early 1990s, Weileder was a student at the Munich Academy of Fine Arts before moving to the School of Visual Arts in New York. For the past few years, he has been resident in England. The conceptual roots of his work undoubtedly lie in American Public Art of the 1960s and 1970s: Richard Serra's first sculptural interventions in the urban spaces of New York City, Gordon Matta-Clark's archaeological retracings, or Siah Armajani's architectural fantasies. Influenced by Massimilano Fuksas' crushingly cynical statement that "the quality of architecture is best measured by the amount of blue sky it allows us to glimpse between buildings",[5] all were evidence of contemporary art's attempts to influence and change curiously life-less urban spaces and to transform them into sites of aesthetic experience. In the 1980s and 1990s, artists such as Dan Graham with his mirror-glass pavilions, or Stephen Craig with his architectural models, made their own contribution to furthering our understanding of the relationship between architecture and art, and its historical, social, sociological, and urban conditions.

bus shelters, 2000
Galerie der Künstler, Munich

Definition des zweiten einen Begriff oder ein Stichwort heraus und erklärt dies… usw., usw. So beginnt ein endloser Kreislauf von Erklärungen und Kommentaren, Berichten und Meinungen, so dass der Verlauf und das Ende der Performance zeitlich und inhaltlich vom Künstler nicht mehr kalkulierbar sind. – Beide Arbeiten, die Architekturskulptur »shelter« ebenso wie die Performance »cage«, behandeln das Verhältnis von Raum und Zeit, von Realität und Virtualtität, wie dies Vito Acconci problematisiert hat. In diesem Sinne sind die beiden Arbeiten als »Vorstudien« zu den seit 2002 realisierten *house-projects* zu verstehen.

Weileder studierte Anfang der neunziger Jahre an der Akademie der Bildenden Künste in München und danach an der School of Visual Arts in New York und lebt seit einigen Jahren in England. Gerade in der amerikanischen Public Art der sechziger und siebziger Jahre sind die konzeptuellen Wurzeln Weileders zu verstehen: Die ersten skulpturalen Eingriffe eines Richard Serra in den New Yorker Stadtraum, die archäologischen Spurensicherungen eines Gordon Matta-Clark ebenso wie die architektonischen Phantasien eines Siah Armajani sind Hinweise auf die Versuche der zeitgenössischen Kunst, merkwürdig leblose Stadträume zu verändern und zu beeinflussen, urbane Räume zu ästhetischen

What all these artistic approaches have in common is that they affirm the city as the central site of human interaction and once again confirm the open public space as a meeting point and trading centre for dialogue and communication.

Read in this context, Wolfgang Weileder's *house-projects* represent both obvious and sometimes – for the casual passer-by – obscure interventions in the spatial structures of the city: the banality of a building site is juxtaposed with a temporary architectural installation apparently devoid of any function. The flâneur becomes a viewer, perhaps even an involuntary actor in this spatial drama. Oscillating between the opposing poles of autonomy and contextuality, Weileder's *house-projects* redefine a specific public space – a square, say, or a road – and transform it into a site its "users" are suddenly able to experience in a radically different way. An anonymous "no-place" becomes a concrete, tangible place – or, with reference to Vito Acconci once again: art reveals itself as the decisive factor that enables us quite literally to "place" fast time in slow space.

Erlebnisräumen werden zu lassen – geprägt von der vernichtend zynischen Kritik eines Massimilano Fuksas: »Die Qualität der Architektur misst man am besten an der Fläche blauen Himmels, die sie für den Blick zwischen den Bauwerken freilässt.«[5] In den achtziger und neunziger Jahren haben dann Künstler wie Dan Graham mit seinen verspiegelten Pavillons oder Stephen Craig mit seinen Architekturmodellen einen weiteren Beitrag zum Verhältnis von Bauwerk und Kunstwerk unter den historischen und gesellschaftlichen, den soziologischen und urbanen Bedingtheiten des Stadtraums geliefert. Gemeinsam ist all diesen künstlerischen Ansätzen, dass sie die Stadt als zentralen Austragungsort menschlichen Zusammenlebens bestärken und einmal mehr den öffentlichen Außenraum als Treffpunkt und Handelsplatz von Dialog und Kommunikation bestätigen.

In diesem Kontext sind die *house-projects* von Wolfgang Weileder als ebenso selbstverständliche, wie aber für den Passant oftmals unverständliche Eingriffe in die urbanen Strukturen des Stadtraumes zu verstehen: Dem banalen Auftreten einer Baumaßnahme wird die zeitlich befristete Installation einer funktionslosen Architektur gegenübergestellt, in der der Flaneur zum Betrachter, ja zum unfreiwilligen Akteur in dieser Szenerie wird. Im Spannungsfeld zwischen Autonomie und Kontextualität wird mit den *house-projects* der jeweils konkrete öffentliche Raum – ein Platz, eine Straße – neu definiert, für seine »Benutzer« anders erlebbar gemacht. Unversehens wird so aus einem anonymen Unort, einem no-place, ein konkreter Ort, ein place, oder – um noch einmal Vito Acconci zu zitieren – »die Kunst ist der zentrale Faktor, der es uns ermöglicht, die schnelle Zeit im langsamen Raum buchstäblich zu ›verorten‹.«

NOTES

1 Vito Acconci: Das Haus verlassen. Anmerkungen zu Einfügungen in die Öffentlichkeit, in: Public Art. Kunst im öffentlichen Raum – ein Handbuch, ed. F. Matzner, 2nd rev. edn., Ostfildern 2004, p. 33.

2 Daniel Buren: Kann die Kunst die Stadt erobern?, in: Skulptur. Projekte in Münster 1997, ed. K. Bußmann, K. König, F. Matzner, Ostfildern 1997, p. 502.

3 Cf. Jean-Christophe Ammann: Plädoyer für eine neue Kunst im öffentlichen Raum, in: Parkett 2, 1984: "Radically speaking, an artist working in a public space ought to strive for the point at which the work as such becomes invisible."

4 Daniel Buren, 1997, (see note 2), pp. 483–84.

5 Qtd. from Bert Theis: Einige Samples, in: Public Art. Kunst im öffentlichen Raum, 2004 (see note 1), p. 79.

FLORIAN MATZNER is a curator and lecturer in Art History at the Munich Academy of Fine Arts. He specialises in curating and publishing on Public Art; recent projects include "Skulptur. Projekte in Münster 1997", "Skulptur-biennale im Münsterland" (1998), "Arte all'Arte" (Tuscany, 1998 and 1999), "Public Art – Kunst im öffentlichen Raum" (2001), "No Art = No City. Stadtutopien in der zeitgenössischen Kunst" (Bremen, 2003).

ANMERKUNGEN

1 Vito Acconci: Das Haus verlassen. Anmerkungen zu Einfügungen in die Öffentlichkeit, in: Public Art. Kunst im öffentlichen Raum – ein Handbuch, hg. von F. Matzner, 2. überarbeitete Auflage, Ostfildern 2004, S. 33.

2 Daniel Buren: Kann die Kunst die Stadt erobern?, in: Skulptur. Projekte in Münster 1997, hg. von K. Bußmann, K. König, F. Matzner, Ostfildern 1997, S. 502.

3 Vgl. dagegen Jean-Christophe Ammann: Plädoyer für eine neue Kunst im öffentlichen Raum, in: Parkett 2, 1984: »Radikal gesehen müsste ein im öffentlichen Raum arbeitender Künstler den Punkt anstreben, in welchem sein Werk als solches gar nicht mehr in Erscheinung tritt.«

4 Daniel Buren 1997 (wie Anm. 2), S. 483–84.

5 Zit. nach Bert Theis: Einige Samples, in: Public Art. Kunst im öffentlichen Raum 2004 (wie Anm. 1), S. 79.

FLORIAN MATZNER ist Kurator und lehrt Kunstgeschichte an der Akademie der Bildenden Künste in München. Sein Arbeitsschwerpunkt sind Ausstellungen und Publikationen zur Kunst im öffentlichen Raum, wie z. B. »Skulptur. Projekte in Münster 1997«, »Skulpturbiennale im Münsterland« 1998, »Arte all'Arte« in der Toskana 1998 und 1999, »Public Art – Kunst im öffentlichen Raum« 2001, »No Art = No City. Stadtutopien in der zeitgenössischen Kunst« in Bremen 2003.

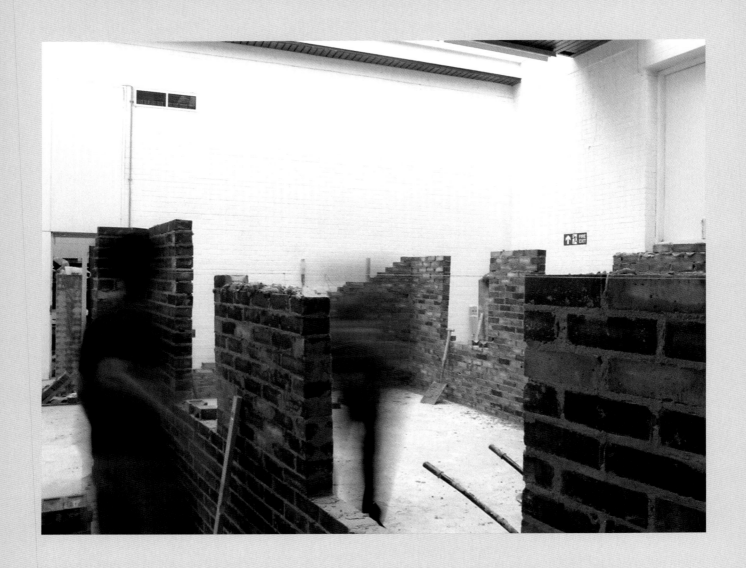

WOLFGANG WEILEDER IN CONVERSATION
WITH NIGEL PRINCE, CURATOR, IKON GALLERY
8 NOVEMBER 2005

Nigel Prince (NP) The *house-projects* – you've made four so far. Let's talk through how the first project came into being, how that developed into the second and the third, and how your thinking concerning this body of work evolved over time.

Wolfgang Weileder (WW) The first project was called *house*, and happened in 2002 at the university where I teach, as part of a twenty-four hour event called 'Connecting Principle'. I proposed to build and un-build a structure equivalent to two intersecting storeys of a typical English house juxtaposed with each other in rotational symmetry. We used red bricks, and a form of training mortar which is mixed with lime instead of concrete, so we could take the walls apart and recycle the bricks. This technique is used to train apprentices at building colleges. The shells were just two metres high so we didn't have to put lintels on the windows. My intention was that every viewer who came to experience the work could join in building. And this happened. It was like a big party.

NP So the people who were doing the building were construction work apprentices and other students?

WW Yes, and the audience itself. Viewers were invited to join in, and instructors and apprentices showed the audience how to do it. Everybody who came to the event built and took down parts

WOLFGANG WEILEDER IM GESPRÄCH MIT
DEM KURATOR DER IKON GALLERY NIGEL PRINCE
8. NOVEMBER 2005

Nigel Prince (NP) Die *house-projects* – es gab bislang vier davon. Lass uns darüber sprechen, wie es zu dem ersten kam, wie es dann weiterging, und wie sich Deine gedankliche Auseinandersetzung mit diesem Werkkomplex im Laufe der Zeit entwickelt hat.

Wolfgang Weileder (WW) Das erste Projekt hieß *house* und fand 2002 an der Universität statt, an der ich unterrichte. Es war Teil eines 24-stündigen Events, das unter dem Titel ›Connecting Principle‹ stand. Ich schlug vor, zwei Rohbauten zu errichten und wieder abzutragen, die einer Etage eines typischen englischen Hauses nachempfunden sind, wobei die beiden identischen Grundrisse, punktsymmetrisch um etwa 190 Grad verdreht, übereinanderliegen. Wir benutzten rote Backsteine und statt Beton einen Kalkmörtel, so dass wir die Wände auseinandernehmen und die Backsteine wieder verwenden konnten. Mit diesem Mörtel werden Maurerlehrlinge hier an den Colleges ausgebildet. Die Rohbauten waren nur zwei Meter hoch, so dass wir keine Fensterstürze einzubauen brauchten. Meine Idee war, dass jeder, der in die Ausstellung kam, wenn er wollte, gleich mitbauen konnte. Was dann auch passierte, es war wie eine große Party.

NP Die Bauleute waren also Lehrlinge aus der Baubranche und Studierende?

of the houses. In total about sixty people worked on this twenty-four hour project, so that some students might find themselves working at three o'clock in the morning.

NP And the forms that were built – the relationship to a residential house?

WW First of all it was indoors, so I was limited by the dimensions of the space, a sculpture studio at the university which was big enough to have a floor plan relating to a standard house form. For me it was more important that the actual shape represented a contemporary dwelling, not a specific type of house. The project was not about representing a house, but about the act of building and un-building.

NP And questioning the idea of a dwelling as opposed to a particular style or design?

WW Yes. And part of it was that the material was so familiar. Coming from the south of Germany where all houses are rendered, one of my first impressions of England was of red bricks. I wanted the first house-project to come out of this. You can see how the houses are constructed; they are not hidden behind a skin. You see that the façade is the construction, which is not necessarily true anymore in post-modernist architecture, where any façade can be 'glued' on. This is why I wanted to work with bricks – the understanding of the work relates directly to its construction.

NP And the form was rectangular?

WW It was a rectangular shape with a little corner section, divided with two walls; basically the front and back room of a conventional house, and each 'room' had windows, some bigger than others.

WW Ja, und das Publikum selbst: Interessierte Besucher wurden eingeladen mitzumachen, und die Ausbilder und Lehrlinge zeigten dem Publikum, was zu tun war. Jeder Besucher des Events war irgendwie am Auf- und Abbau beteiligt. Insgesamt haben etwa sechzig Leute an diesem 24-stündigen Projekt mitgearbeitet, das heißt, einige Studierende waren auch um drei Uhr morgens bei der Arbeit.

NP Und die Form der Baukörper – welchen Bezug gibt es zu Wohnhäusern?

WW Zunächst einmal fand das Ganze drinnen statt, so dass die Dimension des Projekts von vornherein begrenzt war, und zwar auf die Größe eines Ateliers einer Bildhauerklasse, gerade groß genug also, um den Grundriss eines durchschnittlich großen Häusertyps aufzunehmen. Dann war mir wichtig, dass der Rohbau eine zeitgenössische Behausung darstellte. Mir kam es nicht so sehr auf einen spezifischen Häusertyp an. Schließlich ging es in dem Projekt nicht darum, ein Haus darzustellen, sondern um den Akt des Bauens und Abbauens.

NP Ging es auch darum, die Idee einer Behausung als solcher statt eines bestimmten Baustils in Frage zu stellen?

WW Ja, das auch. Und dazu gehörte, dass das Material so vertraut war. Mein erster Eindruck von England war der von rotem Backstein. Ich komme aus Süddeutschland, wo alle Häuser verputzt sind. Mein erstes House-Projekt ist aus diesem Eindruck entstanden. Man kann sehen, wie die Häuser gebaut sind; nichts ist unter einer Schale verborgen. Man sieht, dass Fassade und Baukörper eins sind, was in der postmodernen Architektur, wo irgendeine Fassade aufgesetzt sein kann,

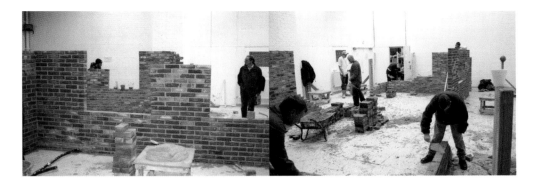

NP The second version of this project, *house-city*, took place in Newcastle city centre, this time out of doors. Was the structure similar and how did it develop *house-projects* overall?

WW The question that arose from the first one was how does this relate to architecture or to the place where it happened? It became clear it would make sense to present a project in a town centre because the context would change it completely; it would raise a new set of questions. For me, there was a logical consequence that the second house project should be outside of a gallery space.

NP This development sets up a very different dynamic whereby the work is apprehended by the audience in the space where they are going about their daily lives; it becomes part of the everyday business of what they engage with.

gar nicht selbstverständlich ist. Deswegen wollte ich mit Backsteinen arbeiten – das Verständnis des Werks hat unmittelbar mit seiner Konstruktion zu tun.

NP Und die Rohbauten waren rechteckig?

WW Ja, mit einer kleinen Eckabflachung und zwei Trennwänden; im Prinzip das Vorder- und Hinterzimmer eines konventionellen Hauses, und jeder ›Raum‹ hatte Fenster, einige größer als andere.

NP Die zweite Version dieses Projekts, *house-city*, fand dann im Stadtzentrum von Newcastle statt, dieses Mal unter freiem Himmel. Sah der Rohbau ähnlich aus, und welchen Einfluss hatte dieses Event auf die Serie der *house-projects* insgesamt?

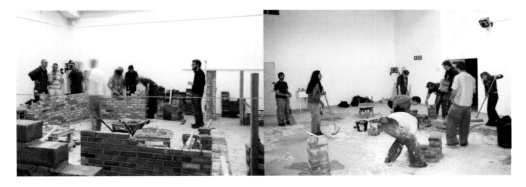

house, 2002

WW Absolutely true. The first project was a gallery situation where it was part of an art event, lots of other artworks around it. The audience, even though they participated, were there on the understanding they were viewing and experiencing art, whereas with the second one, I wanted to remove it from an art context and put it in the real world, in the middle of Newcastle city centre, not as part of an exhibition.

NP So people would come across it not necessarily as an art event?

WW My main audience were not 'art event' people. The audience was whoever passed by. In doing that I was interested in the nature of the event itself. After *house*, I realised the event had potential to create a huge forum for people who would come, watch something happen, stay and discuss it. It activated this public space in Grey Street, Newcastle, and a new conversation could take place.

NP Because you're already in 'public space'?

WW Yes, but the definition of public space that this project created was that it is not just something one passes through to go shopping; it is something that happens when people talk to each other. It goes back to the early ideas of 'the public' being defined by a forum in Rome, where people meet and have experience outside of their private lives, where they talk to strangers. By making this kind of event, providing a set of questions, *house-city* generated an arena and provided the impetus for discussion. Of course, I realised the act of constructing a six metre high wall blocking the central pedestrian area would provoke a reaction.

WW Die Frage, die sich aus dem ersten Projekt ergab, war die nach der Beziehung zwischen Projekt und Architektur bzw. Projekt und Ort des Geschehens. Mir wurde klar, dass das nächste Projekt dieser Art in einem Stadtzentrum stattfinden müsste, weil durch den andersartigen Kontext etwas völlig Neues dabei herauskäme und sich neue Fragen ergäben. Für mich war es ganz folgerichtig, das zweite *house-project* außerhalb einer Galerie stattfinden zu lassen.

NP Die Dynamik, die sich daraus entwickelte, war eine völlig andere, nicht wahr? Du hattest es ja dieses Mal mit einem Publikum zu tun, das in diesem Raum seinen alltäglichen Verrichtungen nachging; das Kunstwerk wurde Teil ihrer Alltagsgeschäftigkeit, Teil dessen, womit diese Menschen tagtäglich zu tun hatten.

WW Ganz genau. Das erste Projekt entsprach einer Galeriesituation, es war Teil eines künstlerischen Events, eingebettet in eine Fülle anderer Kunstwerke. Obwohl viele Besucher zu aktiven Teilnehmern wurden, kamen sie zu der Ausstellung in dem Bewusstsein, man werde Kunstwerke betrachten und auf sich wirken lassen; dagegen wollte ich das zweite Projekt vom allerersten Moment an aus dem künstlerischen Ausstellungskontext befreien und in der Wirklichkeit verankern, mitten im Stadtzentrum von Newcastle.

NP Damit die Leute Dein Projekt nicht notwendigerweise als Kunst-Event wahrnahmen?

WW Mein Publikum bestand nicht aus dem typischen Kunst-Event-Publikum, sondern aus ganz zufälligen Passanten. Mir ging es dabei um das Phänomen Event an sich. Nach *house* war mir klar, dass so ein Event zu einem riesigen Forum für Menschen geraten könnte, die diskutieren,

NP Yes, the very gesture itself…

WW … was a pretty dramatic one. But at the same time it was ambiguous because, interestingly enough, many viewers didn't realise it wasn't an ordinary building site. I had people asking if they could buy a flat there. I couldn't believe this because it seemed so obvious that this was an event, a temporary structure. For some people however, it wasn't clear and this in-between-ness of things I found interesting.

NP This ambiguity you talk about – we're sitting here amidst a city where there is huge regeneration happening, building all around us, so perhaps inevitably there would be this reaction. With *house-birmingham* in Centenary Square, there was inquisitiveness from the audience in terms of what was going on and whether it was to be a permanent structure. Maybe it is something about the very act of building *per se*, that people's expectations are for it to be a permanent rather than temporary thing. However your work gains resonance through those larger issues that seem to be very much a part of urban experience today, to do with the regeneration of large post-industrial cities – the spectacle of such things being out there on the street. I wonder if maybe you could speak a little about that, because I am interested to discuss the comparison with the first project. Here the audience had a participatory role beyond the propositions of the art work, in providing a space to generate a dialogue, in that they could actually take part in the building process. By coming out into public space away from the clearly defined place of an art gallery, the audience was not involved in building as in the first project. This is a crucial difference.

zuschauen und nachher darüber reden wollen. Das Projekt hat letztlich genau dies erreicht: den öffentlichen Raum in der Grey Street in Newcastle elektrisiert und Menschen auf ungewohnte Art miteinander ins Gespräch gebracht.

NP Weil Deine Arbeit ohnehin schon im ›öffentlichen Raum‹ war?

WW Ja, schon, aber der öffentliche Raum, wie ihn dieses Projekt definierte, war mehr als der Raum, den man zum Einkaufen einfach mal durchschreitet; öffentlicher Raum entsteht da, wo Leute miteinander reden. Dieses Verständnis geht auf ganz frühe Konzepte von Öffentlichkeit zurück, nach dem Muster des Forum Romanum, auf dem sich Leute begegnen, Erfahrungen außerhalb ihres Hauswesens machen und mit Fremden reden. Mit dieser Art von Event, das eine Reihe von Fragen aufwirft, schuf *house-city* eine Arena und gab Anstöße zur Diskussion. Natürlich war mir klar, dass der Bau einer sechs Meter hohen Mauer, die das Zentrum der Fußgängerzone empfindlich behindern würde, Reaktionen provozieren musste.

NP Ja, die Geste allein…

WW … war ziemlich dramatisch. Und zugleich zweideutig, denn interessanter Weise fiel den Beobachtern gar nicht auf, dass es sich nicht um eine gewöhnliche Baustelle handelte. Wir wurden sogar gefragt, ob man hier nicht eine Wohnung kaufen könnte. Ich konnte es kaum glauben, es schien doch so offensichtlich zu sein, dass es sich hier um ein Event, einen nur vorübergehend errichteten Bau handelte. Doch einigen war es keineswegs klar, und diese Uneindeutigkeit fand ich besonders spannend.

house, 2002

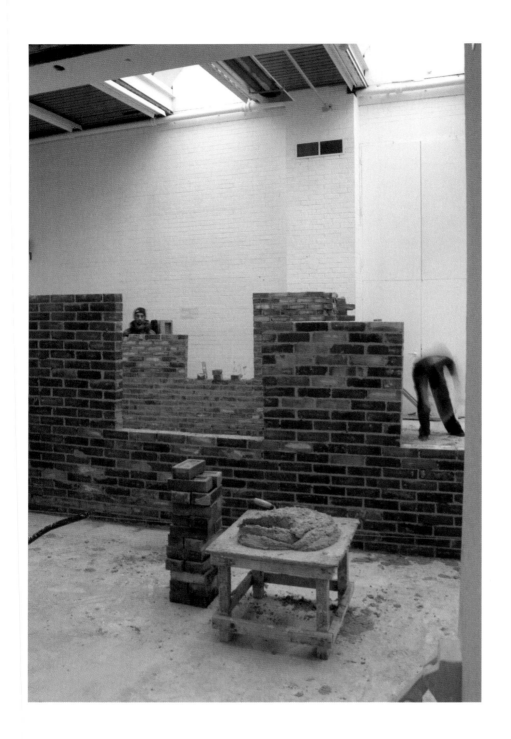

house, 2002

WW But this had to happen, for reasons of health and safety, building regulations and so on, and also the scale of subsequent projects did not allow me to work with the immediate audience, but nevertheless I worked with volunteers – all projects are made on a voluntary basis.

The shift in moving into the public domain and leaving the safe grounds of an art space was, I think, absolutely crucial for the work. It is not so much that the audience actively participates by doing the building itself, it is more about responding to the site and creating new sets of questions. But let me mention a very important point in understanding these projects, concerning the fact that people see it change over a period of time. If they come only once it just looks like a building site, but if they come two or three times then all of a sudden they see that those walls are literally moving; the parameters alter, and the relationship to the city itself changes. It becomes clear that the walls are animated; they become an architectural gesture in time, like a slow dance.

Once people understand that, they come again, sit in coffee shops nearby and take it in as an experience.

NP It is, in a sense, theatre, like the work of other artists such as Gordon Matta-Clark. A lot has been written about the spectacle of the streets in terms of how the audience might begin to understand what was happening before their eyes, how they begin to engage, and how it provokes conversations between people going about their work, seeing this changing vista on a daily basis. Is there something else about the drama of this that you find interesting?

NP Diese Zweideutigkeit, von der Du sprichst… Wir sitzen hier inmitten einer Stadt, in der zur Zeit enorme Regeneration stattfindet, wohin man sieht, Baustellen, und vielleicht war eine solche Reaktion unvermeidlich. Beim Projekt *house-birmingham* auf dem Centenary Square wollte das Publikum wissen, was vor sich ging und ob der Bau stehen bliebe. Vielleicht ist es das Bauen an sich, das bei den Leuten die Erwartung weckt, es eher mit einem permanent als mit einem temporären Phänomen zu tun zu haben. Doch kommt mir Deine Arbeit fast wie ein Echo auf die größeren Themen vor, die heutzutage Teil der städtischen Alltagserfahrung zu sein scheinen und mit der Regenerierung post-industrieller Städte zu tun haben – es ist die Schauseite solcher Themen, sichtbar da draußen in unseren Straßen. Vielleicht könntest Du uns etwas mehr darüber erzählen, weil es mir um den Vergleich mit dem ersten Projekt geht. Da hatte das Publikum ja eine Teilnehmerrolle, die über die Absichten des Kunstwerks, einen Dialograum zu schaffen, hinausging, indem es sich aktiv am Bauprozess beteiligen konnte. Indem Du aus dem klar begrenzten Raum einer Kunstgalerie an die Öffentlichkeit getreten bist, hast Du das Publikum vom eigentlichen Baugeschehen weitgehend ausgeschlossen. Darin scheint mir ein bedeutsamer Unterschied zu liegen.

WW Wegen Arbeitsschutz, Bauvorschriften u. ä. ließ sich das gar nicht vermeiden; außerdem erlaubte mir die Größenordnung der folgenden Projekte nicht, mit dem Publikum an sich zu arbeiten. Dafür habe ich mit Freiwilligen gearbeitet – alle Projekte beruhen ja auf Freiwilligkeit. Der Schritt von den sicheren Gefilden eines Ausstellungsraums in die Öffentlichkeit war, glaube

WW Yes, I think this kind of event is something which includes the audience as a kind of 'extra' because despite the protective fences, there is not really a boundary around the actual building process. The activity creeps out into the whole city centre, and the building apprentices themselves became 'actors' – a completely new role for them – which is manifest through their direct contact and discussion with the audience. So another dynamic within the projects is the interaction between the artwork and the audience; it is through the builders, not me. A very interesting shift happens during this process because initially the builders usually have no idea what they are really doing. They start the project – they are briefed but they can't really imagine things. They say its art, they don't understand it, it's like a job for them, but after a while they begin to understand that something strange is happening because they take things apart that they have just built up.

NP It goes against what they actually do; it raises questions about their actual work.

WW Yes, completely. They are really puzzled and find it difficult to bring down a wall they built five minutes previously. At the same time they begin to understand that they are dealing with something ephemeral, a process, something like a performance and they start to enjoy the whole

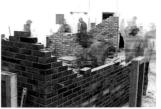

house, 2002
Video stills

ich, für das Werk sehr wichtig. Das Publikum nimmt ja nicht nur Teil, wenn es aktiv am Bauprozess beteiligt ist, sondern auch, indem es auf die Baustelle reagiert und neue Fragen stellt.

Aber lass mich einen sehr wichtigen Punkt für das Verständnis dieser Projekte erwähnen: die Tatsache, dass die Leute den Wandel über einen gewissen Zeitraum wahrnehmen. Kommen sie nur einmal vorbei, sieht alles nach einer Baustelle aus, doch wenn sie zwei oder drei Mal vorbeikommen, erkennen sie plötzlich, dass diese Wände sich, im wahrsten Sinne des Wortes, verschieben; die Parameter ändern sich, und die Beziehung zur Stadt selbst ändert sich ebenfalls. Es wird klar, dass die Wände ein Eigenleben haben; sie werden zu einer zeitabhängigen architektonischen Geste und führen fast so etwas wie einen langsamen Tanz auf. Wer das begriffen hat, kommt gern wieder, sitzt im nahe gelegenen Café und genießt es als Erlebnis.

NP In gewissem Sinne ist es doch Theater, wie das Werk anderer Künstler, z. B. von Gordon Matta-Clark. Es ist viel geschrieben worden über Spektakel auf offener Straße, und wie das Publikum begreift, was sich vor seinen Augen abspielt, wie es sich zu engagieren beginnt, und wie das Event zu Unterhaltungen zwischen Menschen führt, die ihrem Alltag, ihrer Arbeit nachgehen und den sich wandelnden Ausblick tagtäglich verfolgen. Gibt es abgesehen davon etwas, das Du an dem Schauspiel interessant findest?

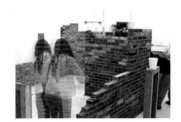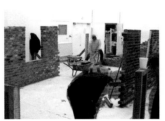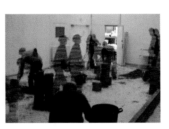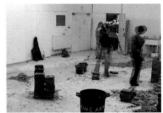

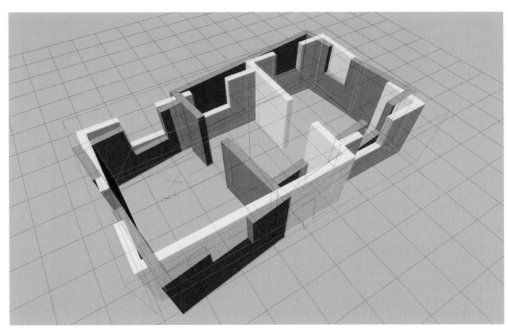

house, 2002
Computer generated
proposal sequence (detail)

activity, particularly the idea of being on a stage. The attention of the audience somehow validates their usual work, questions are asked and they respond, and in every sense they become part of the art work, they engage with it, they take ownership.

NP Interesting because ordinarily, with a normal building site rather than an art work that is using the language of building shall we say, builders are 'on show' anyway and they're part of the fabric of our inner cities. Yet paradoxically there is this twist: is it that the participants, the building apprentices and construction workers become aware of their own practice much more, and so transcend their usual occupation of it being just a regular job? Through conversations with you and the public, there is an apprehension of something fugitive. They are no longer a scaffolder, or the man or woman building a brick wall, suddenly they realise they are involved in a different kind of work, that they are performers.

WW But what they're meant to be and what they do during the event is the same thing, apart from the dismantling. On one hand they are part of this art project and on the other they are receiving different attention for what they usually do, and then there is an aesthetic to building, the process and materials.

NP And there is a certain beauty in something that is well made.

WW Yes, apart from the ideas behind the projects, they are very beautiful things to look at.

NP The change from the grey Thermalite blocks of *house-city* to the white blocks for Madrid and Birmingham meant the light and shadow across the surface of the structures very much added to

WW Ja, durchaus. Ich glaube, so ein Event ist etwas, das das Publikum als eine Art ›Statist‹ einbezieht, denn trotz der Schutzzäune steht im Grunde nichts zwischen ihm und dem aktuellen Baugeschehen. Die Aktivität pflanzt sich über die Zäune hinweg ins gesamte Stadtzentrum fort, die Maurerlehrlinge werden zu ›Schauspielern‹ – eine ihnen völlig neue Rolle – was sich in ihrem direkten Kontakt und ihren Gesprächen mit dem Publikum äußert. Es entsteht also bei meinen Projekten auch eine Dynamik zwischen Kunstwerk und Publikum, wobei es an den Maurern, nicht an mir ist, sie zu entfalten. Dabei kommt es zu einer sehr interessanten Veränderung: Die Bauarbeiter wissen zunächst gar nicht genau, was sie da eigentlich tun. Sie sind zwar von Anfang an dabei, sind unterrichtet, können sich aber kein rechtes Bild machen. Sie sagen, es sei Kunst, ohne etwas zu verstehen. Für sie ist es ein Job, doch nach einer Weile merken sie, dass hier etwas sehr Merkwürdiges vor sich geht, weil sie das wieder auseinandernehmen, was sie eben erst aufgebaut haben.

NP Es widerspricht dem, was sie ansonsten tun; es stellt ihre gewöhnliche Arbeit in Frage.

WW Ja, und wie. Sie sind wirklich verunsichert und demontieren eine Wand, die sie erst fünf Minuten zuvor aufgebaut haben, nur widerwillig. Gleichzeitig wird ihnen bewusst, dass sie es mit etwas Flüchtigem zu tun haben, mit einem Prozess, einer Art Performance, und sie beginnen, das Ganze zu genießen, besonders die Vorstellung, auf einer Bühne zu stehen. Die Aufmerksamkeit des Publikums bestätigt sie in ihrer Arbeit, Fragen werden gestellt, Antworten gegeben, und so werden sie in jeder Hinsicht Teil des Kunstwerks, sie lassen sich darauf ein, machen es sich zu eigen.

house, 2002
Computer generated
proposal sequence (detail)

the beauty of the event, and is revealed so well in the films. The light playing across the concrete blocks, bouncing off the aluminium scaffolding with its bright orange safety markings, all of this makes for a visually arresting scene.

WW Yes. And another aspect of what is important about the *house-projects* is that it is not about the finished structure, it is about building as an event more than the structure that is built. Therefore it is important that I am able to make a project at a large scale, but one which is not monumental. I want to comment on this, not simply make monumental art.

NP Or critique this?

WW I wouldn't say critique but it is certainly a comment. I intend it to be much more open. In one way you can clearly see that somebody is building and taking things apart. You could read this as questioning architecture, questioning town planning, maybe even as chopping away the foundation of architecture. The act of continual deconstruction raises a lot of questions, but one formulates the questions indirectly and with subtlety.

NP So it's not a didactic gesture.

WW Yes, I don't want to do this.

NP I want to go back a little. I am interested in the blur you mentioned between participant and audience, the people who build the work and those who view it; the idea that you develop a community of workers and this notion of community expands outward to encompass the audience as their role and position to the work change. When the events are happening in city

NP Das ist interessant, da ja auf einer normalen Baustelle – nicht in einem Kunstwerk, das gewissermaßen die Sprache des Baugewerbes verwendet – die Bauarbeiter für gewöhnlich sowieso auf dem Präsentierteller stehen und Teil des Erscheinungsbildes unserer Stadtzentren sind. Und doch ist es hier paradoxerweise anders: Kommt es daher, weil sich die Teilnehmer, die Lehrlinge und die Bauarbeiter in weit größerem Maße ihres eigenen Handwerks bewusst werden und so ihre Einstellung, es handele sich um einen gewöhnlichen Bauauftrag, transzendieren? Durch die Gespräche mit Dir und dem Publikum entsteht der Eindruck von etwas Flüchtigem. Sie sind nicht länger Gerüstbauer oder Maurer bzw. Maurerinnen, plötzlich wird ihnen klar, dass sie Teil einer ganz anderen Arbeit sind, dass sie Akteure sind.

WW Doch was ihr eigentlicher Beruf ist und was sie während des Events tun, ist dasselbe, abgesehen von der Demontage. Natürlich sind sie auch Teil dieses Kunstprojekts, und die Aufmerksamkeit, die man ihnen schenkt, ist eine ganz andere als die, die sie gewöhnt sind. Hinzu kommt die Ästhetik des Bauens, des Prozesses und der Materialien.

NP Und auch eine gewisse Schönheit in dem, was gut gemacht ist.

WW Ja, ganz abgesehen von den Ideen, die hinter den Projekten stehen, sind die »Häuser« auch schön anzuschauen.

NP Dass Du die grauen Thermalite-Blöcke von *house-city* durch die weißen Blöcke für Madrid und Birmingham ersetzt hast, hatte zur Folge, dass Licht und Schatten auf den Oberflächen der Strukturen sehr zum ästhetischen Reiz des Events beitrugen. Das kommt auch gut in den Filmen heraus.

centres, as direct feedback from the audience, presumably you've heard a whole range of responses, from very favourable through to very negative. I wonder if there are any particular comments or observations that the public made that have stuck in your memory in relation to your intention.

WW Generally different types of conversation happen: discussions amongst the people on the site itself, the builders, their exchanges with the audience and then the media coverage. In Newcastle, local newspapers had daily updates on the project – on the front page even – which was great. Journalists directly responded to comments they got from the pedestrians; which lead to a public discussion within the media as well.

NP It is interesting that your work provokes that response with regard to our earlier discussion concerning your intention that the events act as spaces for dialogue.

WW Yes, primarily they receive positive exchanges, people say they enjoyed sitting there and watching for half an hour. Of course there are those usual comments concerning wastage of tax-payer's money, but one thing in particular stuck in my mind from Newcastle. There was an elderly person who complained everyday about the project but at the end he said it really grew on him, meaning as much to him as the rest of the city. It made me aware that our relationship to architecture can be something very ephemeral. But I have to say, I am not usually the person that has the conversations with the audience because I want to step back as an artist, in the way that a director doesn't perform. I hand it over to the construction team of builders and apprentices,

Das Licht, wie es um die Betonblöcke spielt, vom Aluminiumgerüst mit seinen orangefarbenen Sicherheitsmarkierungen abprallt, all dies trägt zu einem visuell fesselnden Bild bei.

WW Das stimmt. Und was auch noch wichtig für die *house-projects* ist, ist die Tatsache, dass es nicht um fertige Gebäude geht, es geht vielmehr ums Bauen als Event, weniger um den Baukörper, der entsteht. Daher ist es für mich wichtig, dass ich in der Lage bin, ein Projekt von einiger Größe durchzuführen, ohne dass es monumental wird. Ich möchte das Bauen kommentieren, nicht einfach monumentale Kunst kreieren.

NP Oder letztere kritisieren?

WW Das würde ich nicht gerade sagen, doch ein Kommentar ist es allemal. Ich möchte mein Werk nicht auf solche Festlegungen reduzieren es vielmehr offen halten. Natürlich kann man sofort erkennen, dass da jemand etwas baut und es wieder abbaut. Man kann das lesen als ein Infragestellen von Architektur, ein Infragestellen von Stadtplanung, vielleicht sogar als Etwas, das der Architektur die Fundamente entzieht. Das permanente Dekonstruktionsgeschehen impliziert viele Fragen, aber man formuliert die Fragen indirekt und eher subtil.

NP Es handelt sich also nicht um eine didaktische Geste?

WW Ganz recht. Das möchte ich tunlichst vermeiden.

NP Ich möchte noch einmal einen Schritt zurückgehen. Mich interessiert, wie sich die Trennschärfe zwischen Teilnehmern und Publikum verwischt, zwischen denen, die das Werk gebaut haben, und denen, die es angeschaut haben; mich interessiert die Idee, dass Du eine Gemeinschaft von

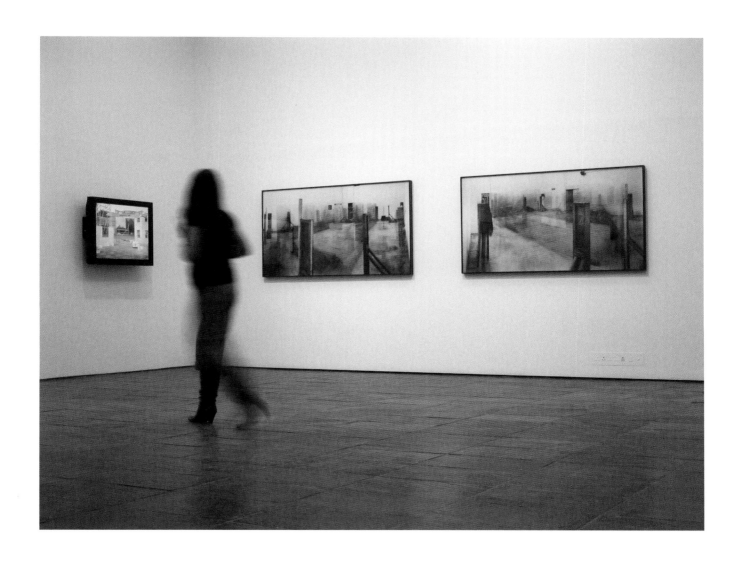

Installation view from
You shall know our velocity, 2006
Baltic Centre for Contemporary
Art, Gateshead

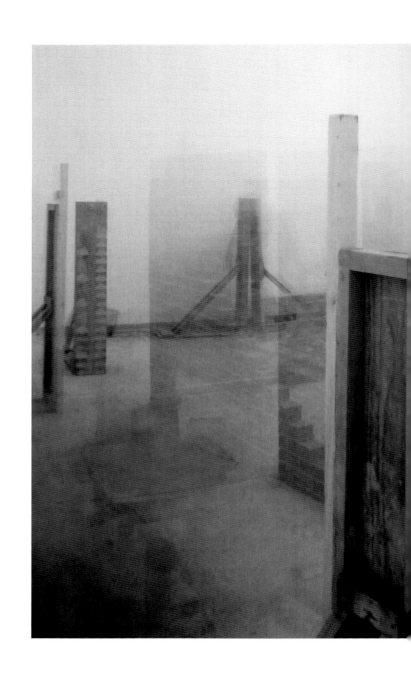

house_1, 2002
Gelatin silver print
97 x 180 cm

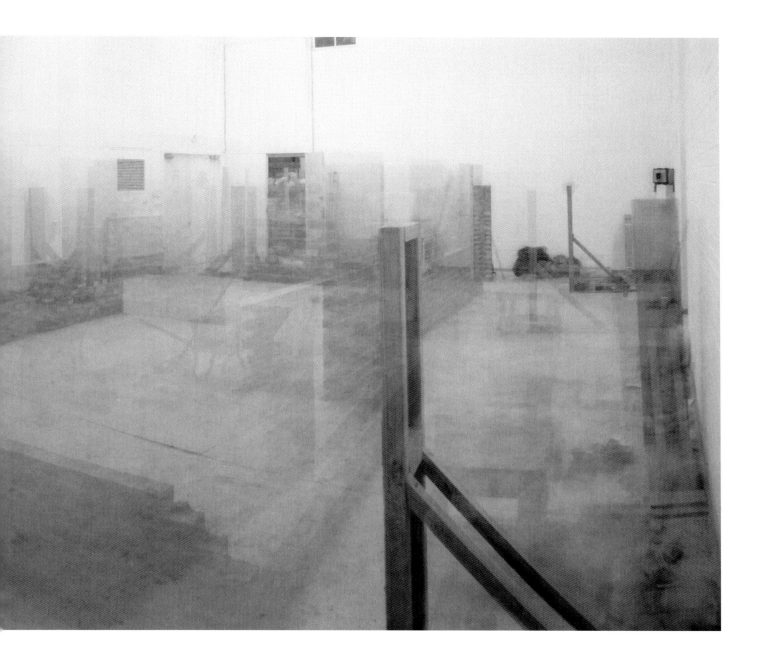

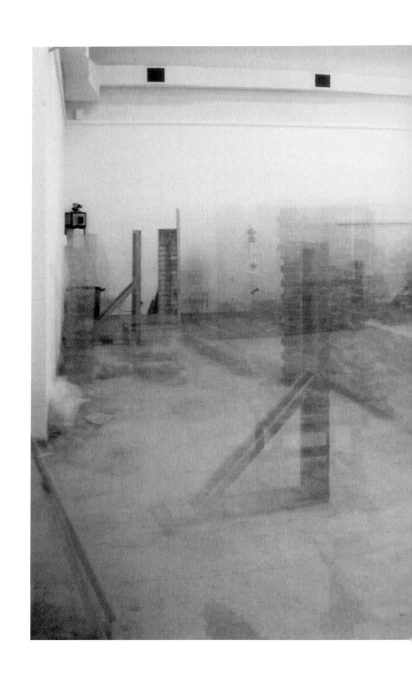

house_2, 2002
Gelatin silver print
97 x 180 cm

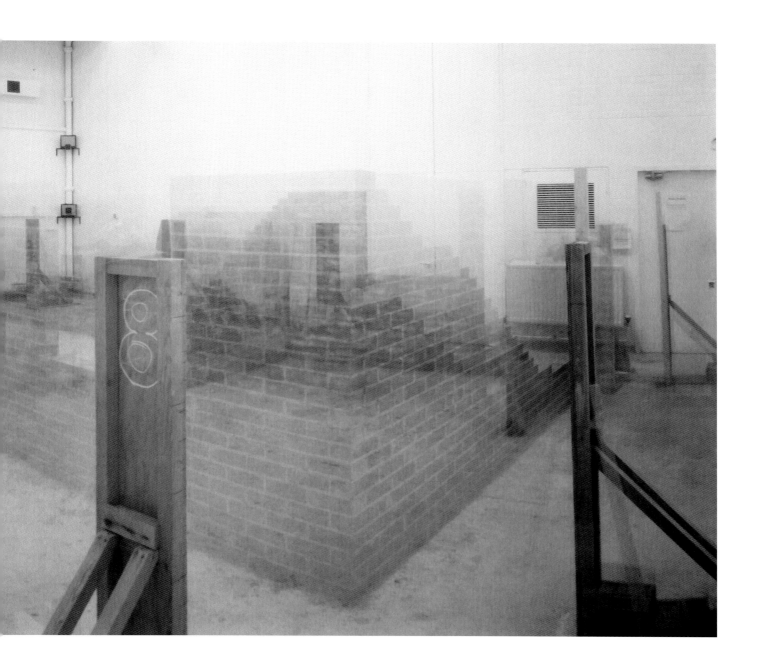

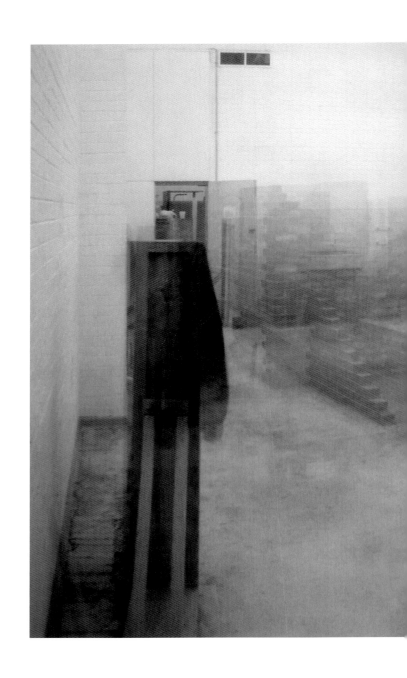

house_3, 2002
Gelatin silver print
97 x 180 cm

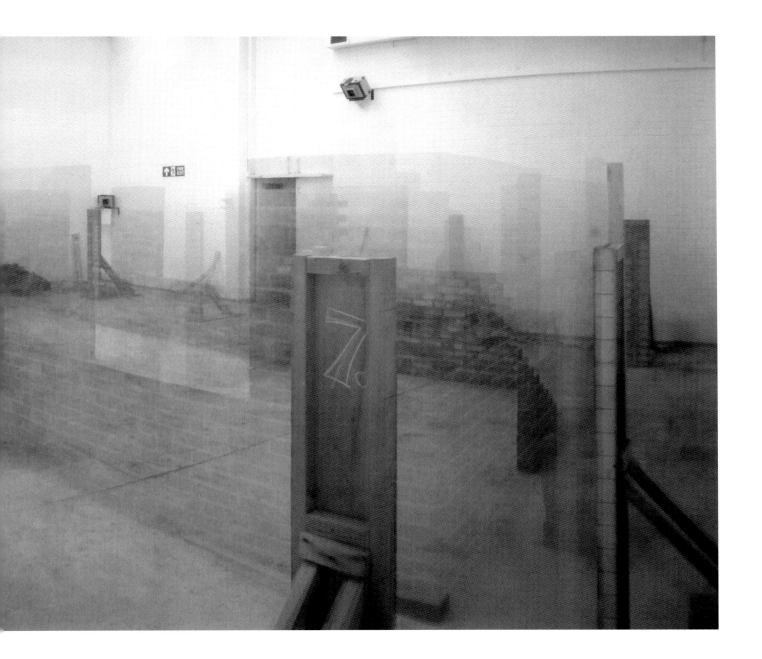

curators and invigilators, the actors. They take on the responsibility, they hold conversations with the audience, and become the mediators of the project.

NP This seems to relate again to the notion of the event as some form of drama. Do you see your own position as an artist amongst this company in a role that is perhaps akin to theatre or film making in some way?

WW I have different roles. Sometimes I am a builder if there is a shortage of people to do the construction on certain days. In this function of course, I talk to viewers, but when I am not building, I become like a director who has an overview as the work takes on a life of its own. I initiate the project but it is realised through many contributors – builders, planners, and the whole city – so the art work begins at least half a year before the actual building work starts, because of negotiations with all parties involved. Everybody contributes and I'm open to that. It is important to me that people take ownership, and that I work with local people with an understanding that it's their house. I initiate it and then I can step back – that's my role as an artist.

NP You mentioned that the first project used red brick and training mortar. Subsequent projects have used other kinds of building technologies. Why make this change and how, both pragmatically and conceptually, does that fit with your intention for readings of the work?

WW After working with brick and mortar indoors, for practical reasons it became clear that I could not use this material in an outdoor context to develop the work as intended. It wouldn't be

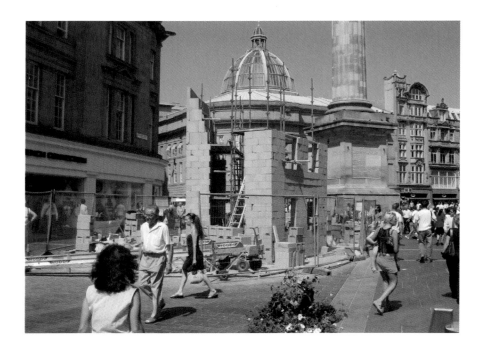

house-city, 2003

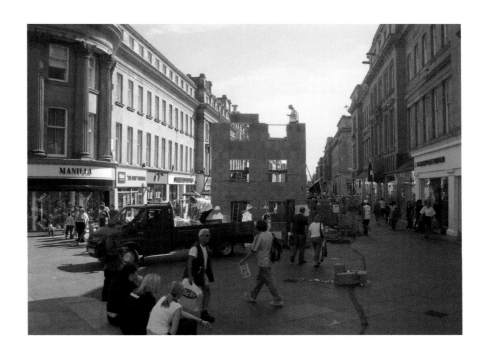

Arbeitern schaffst, die dann auch das Publikum mit einbezieht, in gleichem Maße, in dem sich die eigene Rolle und Einstellung zu dem Werk wandelt. Bei den Events, die mitten in Stadtzentren stattfanden, hast Du als unmittelbares Feedback vom Publikum sicher eine ganze Reihe von Reaktionen gehört, positive wie negative. Ich wüsste gern, ob einzelne Kommentare oder Beobachtungen von Seiten des Publikums Dir besonders im Gedächtnis geblieben sind, gerade im Hinblick auf Deine Absicht.

WW Insgesamt lässt sich sagen, dass es zu ganz unterschiedlichen Gesprächen kommt: Diskussionen unter den Leuten auf der Baustelle, den Bauarbeitern, deren Gespräche mit dem Publikum, nicht zu vergessen die Berichterstattung in den Medien. In Newcastle brachten die Zeitungen täglich einen Situationsbericht über das Projekt – sogar auf der Titelseite – was wirklich großartig war. Journalisten reagierten unmittelbar auf Bemerkungen, die sie von Passanten aufschnappten; so entstand eine öffentliche Debatte auch in den Medien.

NP Ich finde es spannend, dass Deine Arbeit solche Reaktionen provoziert, gerade im Hinblick auf das, was wir vorhin besprochen haben, nämlich Deine Absicht, die Events sollten Raum schaffen fürs Gespräch.

WW Ja, irgendwie stoßen meine Projekte auf ein überwiegend positives Echo; die Leute sagen, es habe ihnen gefallen, da zu sitzen und dem Geschehen eine halbe Stunde zuzuschauen. Natürlich hört man auch die üblichen Kommentare von wegen verschwendeter Steuergelder, doch eins ist mir aus Newcastle besonders im Gedächtnis geblieben: Einer der Passanten, ein älterer Herr, der

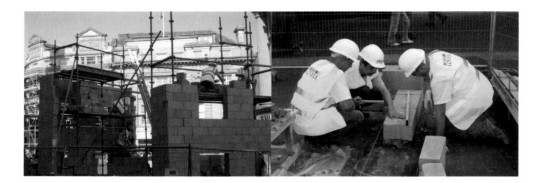

stable enough, especially building to height during short periods of time. I had to increase scale in order to respond to the site directly. Beginning with *house* which was indoors, and made from bricks, I moved onto *house-city*, presented now in the public context of a city centre. The structure needed to be at least six and a half metres high in order to have a strong presence and dialogue with the surrounding architecture. To deal with this, I contacted a company in Sunderland, R. BAU, who uses continental building technologies different from bricks and mortar, called thin joint and dry joint technology.

For *house-city* in Newcastle, we used thin joint technology which uses a lightweight concrete block that can be built very quickly to any height, 'stuck' together with a mortar bed similar to glue.

sich jeden Tag über das Projekt beschwerte, doch am Ende sagte, es sei ihm ans Herz gewachsen und bedeute ihm nun so viel wie der Rest der Stadt. Diese Begegnung führte mir noch einmal deutlich vor Augen, wie wandelbar unser Verhältnis zur Architektur sein kann. Doch muss ich einschränkend sagen, dass ich für gewöhnlich nicht derjenige bin, der mit dem Publikum redet, weil ich als Künstler lieber im Hintergrund bleibe, so wie ein Regisseur, der ja auch nicht die Bühne betritt. Ich überlasse das dem Bauteam, den Maurern und Lehrlingen, Kuratoren und Aufsichtspersonen, kurzum den Schauspielern. Sie tragen die Verantwortung, sie führen die Gespräche mit dem Publikum und werden so zu Mittlern des Projekts.

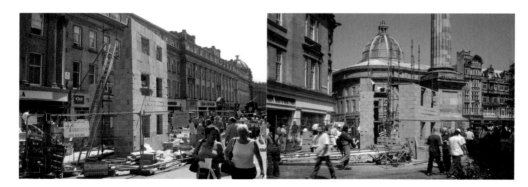

house-city, 2003

Since this is a new building technology in England, I immediately had support for this project from block manufacturers and the construction industry as they could showcase it in this kind of event – the UK is potentially a huge new market for this process and material. Without this technology I would never have been able to realise the project in the way I wanted.

NP So it becomes a selling point to encourage collaboration?

WW Yes, during *house-madrid*, when I was looking for volunteers from local building colleges they immediately joined in, as they knew this would be an opportunity for them to learn about these new technologies. In a way the project helped form a link between building colleges and new industry.

NP … and so establishing a nexus expanding their effect and adding another layer of dialogue and exchange.

WW Yes. I would never have expected that, and this developed with *house-birmingham* to a much bigger scale. The support for *house-city* was crucial but by the end what I did not like was the aesthetics of the blocks, which were grey, and because they were glued together, a large percentage of the blocks broke, creating great wastage. Even though the building colleges took much of this away and reused it for training purposes, the idea of wastage was unappealing. When I had the opportunity to develop the third project, *house-madrid*, R. BAU introduced me to a better technique, dry joint, where blocks are clicked into each other using a specific system so they can be taken apart without damage. It's like Lego.

NP Das scheint wieder mit dem Verständnis des Events als einer Form des Schauspiels zu tun zu haben. Siehst Du gewisse Ähnlichkeiten zwischen Deiner Rolle als Künstler inmitten der Akteure und der des Theater- oder Filmemachers?

WW Meine Rolle in all dem ist vielfältig. Manchmal werde ich selbst zum Bauarbeiter, wenn wir an bestimmten Tagen knapp an Leuten sind. In dieser Rolle spreche ich natürlich mit den Passanten, doch wenn ich nicht selbst auf der Baustelle arbeite, werde ich quasi zum Regisseur, der den Überblick behält, während die Arbeit durchaus ein Eigenleben entwickelt. Ich initiiere das Projekt, doch verwirklicht wird es durch zahlreiche Mitarbeiter – Bauarbeiter, Planer und die ganze Stadt – mit anderen Worten, die künstlerische Arbeit beginnt bereits ein halbes Jahr vor dem eigentlichen Bauprozess, allein schon wegen der Verhandlungen mit allen Beteiligten. Jeder trägt zum Gelingen bei, und das ist mir ganz recht. Es ist mir wichtig, dass sich Menschen das Projekt zu eigen machen, dass ich mit Leuten vor Ort arbeite, die verstehen, dass es sich um ihr Haus handelt. Ich gebe den Anstoß, doch dann nehme ich mich zurück – darin sehe ich meine Rolle als Künstler.

NP Du erwähntest, dass im ersten Projekt rote Backsteine und eine bestimmte Art von Mörtel verwendet wurden. Bei den folgenden Projekten habt Ihr auf andere Bautechniken zurückgegriffen. Wie kam es zu dieser Veränderung, und inwiefern passt das – pragmatisch und konzeptuell – zusammen mit dem, wie Du die Arbeit verstanden wissen willst.

WW Nachdem ich mit Backsteinen und Mörtel in einem Innenraum gearbeitet hatte, war schon aus praktischen Gründen klar, dass ich dieselben Materialien nicht in einem Bauprojekt unter

NP This points to an interesting dialogue whereby the technology that you used for the Madrid and Birmingham projects, in its economy, was much closer to *house* using training mortar than to *house-city*. Through the evolution of the four projects, your relationship with the construction industry and the particular company you worked with was very much a two-way dialogue. They were passing on experience and information, and in a sense understanding what your proposition was, in terms of how the projects should change and evolve during the period of the actual events.

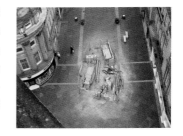

WW Absolutely, yes. By introducing me to new technology they allowed me to think at a different scale, in a different way. I learnt about new building technologies enabling me to be more ambitious.

NP … to build to a dimension and scale in city centres whereby a very tangible relationship is established with the environment for the work, in a formal, as well as a conceptual sense.

WW When you first introduced me to Centenary Square it became clear that focusing on a vertical dimension wouldn't create the right presence. I had to emphasise the horizontal to claim the space. It was interesting for me to hear that during the redevelopment of Birmingham, terraces originally occupying the site had been demolished, so it provided an opportunity to introduce a historical context into my work as well, adding a new dimension.

NP So you might say there is an increasing degree of a context-specific quality to the overall *house-projects*? Does this apply to all versions?

freiem Himmel würde verwenden können, um die Arbeit wie geplant fortzuentwickeln. Backstein und Mörtel wären nicht stabil genug gewesen, zumal für schnelles In-die-Höhe-Bauen. Die neue Lokalität erforderte ja ganz andere Dimensionen. Nach *house*, das im Inneren eines Gebäudes stattfand und bei dem Backsteine verwendet wurden, realisierte ich *house-city*, das sich nun im öffentlichen Raum eines Stadtzentrums präsentierte. Die Konstruktion musste mindestens sechseinhalb Meter hoch sein, um die nötige Präsenz zu erzielen und mit der umgebenden Architektur in einen Dialog eintreten zu können. Ich setzte mich mit der Firma R.BAU in Sunderland in Verbindung, die zwei auf dem Kontinent verwendete Bautechniken einsetzt, die sich vom Bauen mit Backsteinen und Mörtel unterscheiden. Sie heißen Dünnbett-Mörteltechnik und Trockenstapelbausystem.

Für *house-city* in Newcastle verwendeten wir die Dünnbett-Mörteltechnik, bei der Leichtbetonblöcke zum Einsatz kommen, die sehr rasch in die Höhe geschichtet werden können und mittels eines klebstoffähnlichen Mörtelbetts zusammenhalten. Da diese Bauweise in England neu ist, fand ich von Seiten der Herstellerfirmen solcher Leichtbetonelemente und der Bauindustrie sofort Unterstützung für mein Projekt, da sie diese Bautechnik bei einem derartigen Event präsentieren konnten – schließlich ist Großbritannien ein attraktiver neuer Markt für dieses Verfahren und die entsprechenden Materialien. Ohne diese Technologie hätte ich das Projekt niemals in meinem Sinne verwirklichen können.

NP Hier schlägt also das Angebot zur Kooperation in ein Verkaufsargument um?

WW All of the *house-projects* have a very direct relationship to the city, primarily through the floor plan and shape of the houses developing out of the location itself; they always respond in some way to the surrounding architecture. In Newcastle it was the now pedestrianised Georgian streets in the central shopping area; in Birmingham it was the vast, open space of the public square on one hand and on the other, the history of the place.

NP This connects with the photographs you make, as something distinct to the event – they possess an almost phantom-like quality. The images operate in an interesting way revealing the specific process that has occurred over a period of time, in the case of Birmingham, twelve days, but at the same time there's also a broader sense that the photograph visualises something that used to be. They deal with time in a different way to the live event.

The photographic record is obviously a very important aspect of the project in terms of its relationship to the site, its daily audience, and so on. There are the daily conversations that occur, the passage of time that is revealed months later when you meet somebody who happened to see the project because they travelled past the location daily. So there's a sense of the life of the project – by experience or by word of mouth – entering the folklore of the city in a different way. It is no longer tangible in terms of concrete blocks but it's a presence within the memories of people who apprehended it; it's there within the conversations that continually unfold when people talk about their experience of the city in some way. This engagement with the notion of time is further revealed through the photographs and films that you make as components of the overall projects.

WW So könnte man sagen. Als ich mich für *house-madrid* an örtlichen Berufsfachschulen für Maurer nach Freiwilligen umsah, wurde ich sofort fündig, da die Betreffenden wussten, dass dies eine Gelegenheit war, besagte Bautechniken zu erlernen. In einem gewissen Sinne hat das Projekt eine Brücke zwischen Berufsfachschulen, an denen Maurer ausgebildet werden, und einem neuen Industriezweig geschlagen.

house-city, 2003

NP … und so eine Verbindung geknüpft, die den Wirkungsgrad dieser Technologie vergrößerte und dem Projekt eine weitere Dialog- und Austauschebene bescherte.

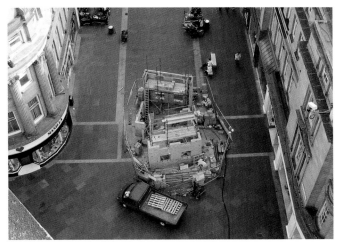

WW Ja. Ich hätte diese Entwicklung, die mit *house-birmingham* ganz andere Dimensionen erreichte, selbst nicht erwartet. Die Unterstützung, die ich für *house-city* erhielt, war maßgeblich, doch am Ende gefielen mir die Betonblöcke wegen ihrer grauen Farbe nicht sonderlich, zumal ein Großteil von ihnen wegen der Verklebungstechnik bei der Demontage entzweibrachen und wir daher recht viel Abfall produzierten. Obwohl uns die Berufsfachschulen die defekten Blöcke abnahmen, um sie für Ausbildungszwecke wieder zu verwenden, behagte mir der Gedanke an Materialverschwendung nicht. Als ich die Gelegenheit hatte, das dritte Projekt, *house-madrid*, zu planen, machte mich R.BAU

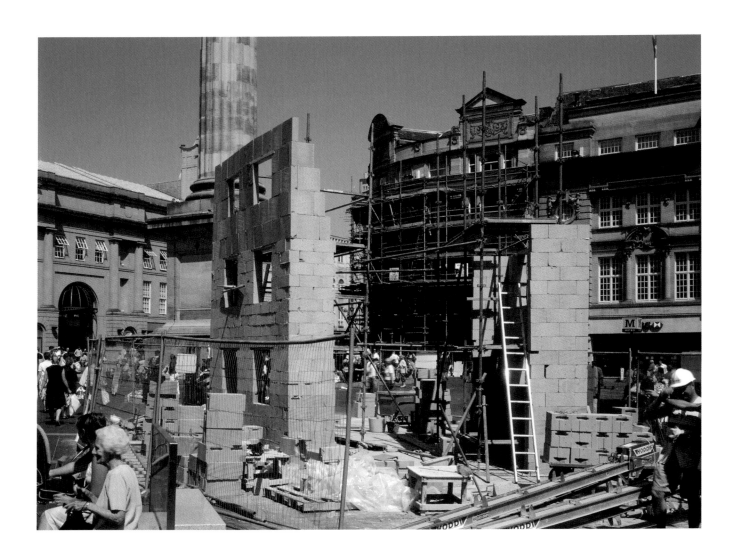

house-city, 2003

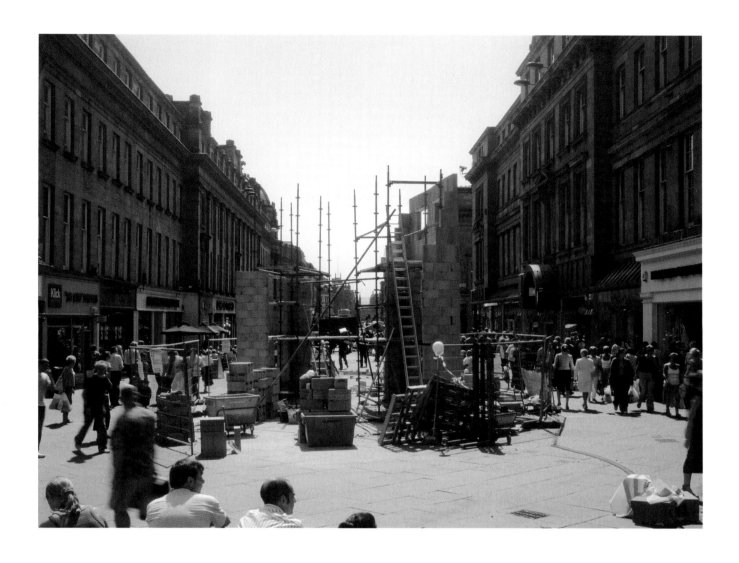

house-city, 2003

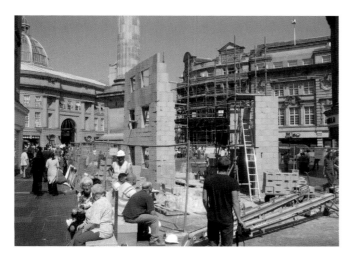

WW In terms of the live event it is a process which stretches over a specific period, like a theatre performance, with a beginning and an end, so it's a time-based project – it constantly changes. The photographs are a recording of this. It is important to say recording rather than documentation, as documentation implies merely that. The distinction for me is that the photographs operate as a discrete work and articulate something else. They are made by opening the shutter at the beginning of the project and closing it at the end. I physically catch all the light emitted from the process of the event on to a single analogue film plate. This kind of recording not only captures all the activity, it also reveals the only complete view of the project. During the *house-projects* you never see a complete building, only parts of it, but with the photographs you get an idea of what the building would have looked like in the form of a ghostly image. I deliberately use analogue, black and white photography for its historical context and the associations with the document.

NP The indexical quality of it?

WW Yes. I wanted to emphasise it by physically catching all light, developing the negative and transferring it through light into a print, without having manipulated it digitally. It is a direct record

auf eine bessere Maurertechnik aufmerksam, das Trockenstapelbausystem nämlich, bei dem Blöcke unter Verwendung eines besonderen Verfahrens aufeinandergesteckt werden und sich wieder abnehmen lassen, ohne dass sie zu Bruch gehen. Es ist fast wie Lego.

NP Damit weist Du auf einen interessanten Dialog hin, durch den die für die Projekte in Madrid und Birmingham verwendeten Techniken in ihrer größeren Wirtschaftlichkeit dem ersten Projekt, bei dem Kalkmörtel verwendet wurde, näher standen als dem zweiten. Im Zuge der Entwicklung der vier Projekte lässt sich Dein Verhältnis zur Bauindustrie bzw. zu der Firma, mit der Du zusammengearbeitet hast, als ein wechselseitiges charakterisieren. Deren Beitrag war die Bereitstellung von Informationen und Erfahrung sowie ein gewisses Verständnis für Dein Konzept vom Ablauf und der Durchführung der Projekte.

WW Ganz recht. So war es. Indem sie mich mit einer neuen Technik bekannt machten, erlaubten sie mir, in anderen Dimensionen zu denken und neue Möglichkeiten in Betracht zu ziehen. Die Auseinandersetzung mit neuen Bautechniken erlaubte mir, ambitionierter zu denken…

NP … und inmitten von Stadtzentren in Größenordnungen zu bauen, die eine fühlbare Beziehung zwischen deiner Arbeit und seiner architektonischen Umwelt in formaler wie konzeptueller Hinsicht erlauben.

WW Als Du mich zum ersten Mal auf dem Centenary Square in Birmingham herumführtest, wurde mir sehr bald klar, dass ein Bau in die Vertikale nicht für eine adäquate Präsenz sorgen würde. Es galt, die Horizontale zu betonen, um den Raum zu besetzen. Es war sehr spannend für mich zu

house-city, 2003
Computer generated
proposal sequence

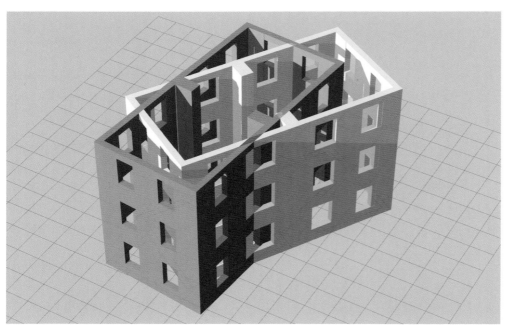

of the project; it has not entered a different language, a different dimension. All *house-projects* have this kind of recording, compressing the time of the event into one object, the single moment of a photograph.

NP And the films, how do these work in relation to other elements of the overall projects?

WW The time-lapse movies developed and changed throughout these projects. For *house*, the first one was made purely as documentation. When I saw the footage I realised it was really beautiful to see the movement of the walls, so for the second one I tried to develop it as a separate work. It failed as two cameras were broken and one stolen, but for *house-madrid* I knew exactly how to handle the technical problems and the idea developed to present the footage in a gallery installation. There were two cameras angled directly opposite each other at the event with the intention that the resulting films would be screened as looped projections in actual scale, whereby the viewer finds him or herself in the middle and can't see both screens at the same time, therefore becoming part of the action.

NP So it positions the audience in the centre of the activity rather than as a viewer from the outside?

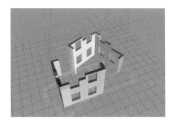 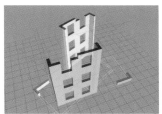 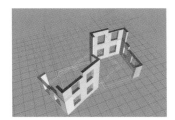

hören, dass man im Zuge der Sanierung von Birmingham auch ganze Häuserreihen auf diesem Platz abgerissen hatte; es gab mir nämlich die Möglichkeit, auch einen historischen Kontext in meiner Arbeit einzufangen und ihr somit eine weitere Dimension zu eröffnen.

NP Kann man also sagen, dass die *house-projects* von Mal zu Mal immer stärker durch den spezifischen Kontext, in dem sie stattfanden, geprägt waren? Trifft dies auf alle Einzelprojekte zu?

WW Sämtliche *house-projects* stehen in unmittelbarer Beziehung zu dem Ort, an dem sie stattfinden, vor allem was den Grundriss und die Form der Bauten betrifft, die sich jeweils aus deren Standort entwickeln; sie reagieren unterschiedlich auf die sie umgebende Architektur. In Newcastle waren es die inzwischen zur Fußgängerzone erklärten Georgianischen Straßen, die Einkaufsmeile der Innenstadt; in Birmingham war es der riesig weite Raum eines öffentlichen Platzes einerseits und dessen Geschichte andererseits.

NP Das leitet zu den Fotos über, die Du von dem Event machst und die zugleich etwas ganz anderes darstellen – ihnen haftet etwas von einem Spukbild an. Die Bilder haben die interessante Aufgabe, den jeweiligen Bauprozess, der sich über eine gewisse Zeit – im Falle Birmingham waren es zwölf Tage – erstreckt, erkennen zu lassen, zugleich aber in einem umfassenderen Sinne etwas visuell festzuhalten, was einmal existierte. Sie gehen mit dem Phänomen Zeit anders um als das Event selbst.

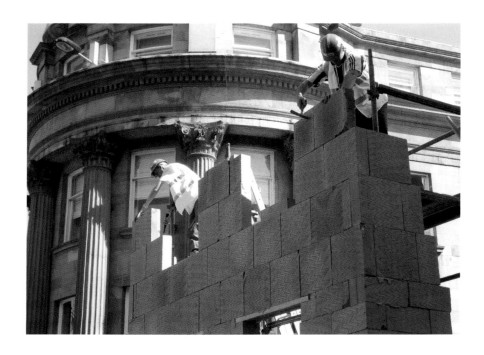

Der fotografische Nachweis stellt selbstverständlich einen wichtigen Aspekt des Projekts dar, vor allem, was dessen Beziehung zum Bauplatz, zum tagtäglichen Publikum und dergleichen angeht. Man denke an die Unterhaltungen, die Tag für Tag stattfinden, an die Zeit, die verstreicht, was einem erst so recht bewusst wird, wenn man später jemanden trifft, der das Projekt zufällig mit eigenen Augen gesehen hat, weil es auf seinem Weg lag. Man könnte geradezu von einem Nachleben des Projekts sprechen, das via Erfahrung oder Mundpropaganda Eingang in das kulturelle Gedächtnis einer Stadt findet. Es ist zwar nicht mehr unmittelbar als Steinkonstruktion erfahrbar, doch es ist im Gedächtnis all jener verankert, die es unmittelbar wahrgenommen haben; es wird zum Bestandteil von Unterhaltungen, die Menschen ja ständig über ihre Erfahrungen mit der Stadt miteinander führen. Die Auseinandersetzung mit dem Phänomen Zeit wird durch die Fotografien und Filme, die Du als Teil der Projekte anfertigst, unterstrichen.

WW Was das Live Event angeht, so handelt es sich um einen Prozess von festgesetzter Dauer, ähnlich einer Theateraufführung. Es hat einen Anfang und ein Ende, ist also zeitgebunden und zudem permanentem Wandel unterworfen. Die Fotografien sollen diesen Prozess aufzeichnen. Wohlgemerkt aufzeichnen, nicht dokumentieren, weil eine Dokumentation über das Event nicht hinausginge. Der Unterschied besteht in meinen Augen darin, dass die Fotos eigenständige Kunstwerke sind und etwas anderes aussagen als das Event. Sie werden angefertigt, indem ich am Beginn des Projekts die Blende öffne und sie an dessen Ende wieder schließe. Physikalisch gesehen sammele ich durch diese Langzeitbelichtung das ganze Licht, das das Event aussendet, auf einer einzigen

house-city, 2003

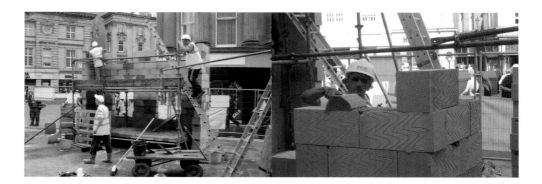

WW Yes. With *house-birmingham* I had the opportunity to take this a step further introducing a moving camera. I wanted to underline the idea of movement across all aspects of the event, so for twelve days the camera circled the building and dismantling process, beginning at the start of the project and stopping at the same point at the end. This produced an endless loop of activity which constantly changes, the slow movement of the camera contrasting with the frantic speed at which the site evolves.

NP I think the film work that developed as part of the Birmingham project is visually very rich. The fact that it is no longer a static camera introduces the horizontal rotation circling the building work and contrasting with the verticality of walls coming up and down. Then there is the quality

analogen Filmschicht. Diese Art der Aufzeichnung fängt nicht nur das gesamte Geschehen ein, sondern liefert auch die einzige Gesamtansicht des Projekts. Während der *house-projects* sieht man niemals das komplette Gebäude, nur Teile davon, doch mit Hilfe der Fotos erhält man in Gestalt eines Spukbildes einen Eindruck davon, wie das fertige Gebäude ausgesehen hätte. Ich verwende bewusst die analoge Schwarz-Weiß Photographie, weil sie den historischen Kontext herausstellt und das Dokumentarische assoziiert.

NP Wegen ihrer Indexqualität?

WW Ja, auch. Mir kam es darauf an, alles Licht wirklich einzufangen, das Negativ zu entwickeln und auf Fotopapier auszubelichten, ohne es dabei digital zu übertragen. Das Foto stellt eine getreue Aufzeichnung des Projekts dar; es wird in keine andersartige Sprache oder Dimension eingespeist. Diese Art der Aufzeichnung ist allen *house-projects* gemein, wobei sie die gesamte Projektdauer in einem einzigen Objekt, dem Augenblick eines Fotos, bündeln.

NP Und wie steht es mit den Filmaufnahmen? Was ist deren Beziehung zu den übrigen Komponenten der Projekte?

WW Die Zeitrafferfilme sind im Laufe der Projektserie ständig weiterentwickelt worden. Für das erste Projekt *house* wurden sie lediglich zu Dokumentationszwecken gedreht. Als ich mir das Filmmaterial ansah, entdeckte ich, wie schön es war, die Bewegung der Wände zu sehen. Also versuchte ich bei dem zweiten Projekt, die Filme zu eigenständigen Arbeiten weiterzuentwickeln. Zunächst ist es nicht geglückt, da zwei Kameras ausfielen und eine dritte gestohlen wurde. Doch

of light arcing across the square from daybreak to darkness, with shadows moving round the structure. Further, the blurred depictions of the people working on the project, darting in and out, creates this network of movement amongst the walls, so it becomes a very complex matrix of all different kinds of movement, on vectors of space and time.

WW And it was a very neat component that the whole process took twelve days. In a way the circle links back to our understanding of time, divided into twelve units; the project is like a big clock.

NP Thinking ahead now. You said at the beginning that these four *house-projects* are as far as the series go. As a method of working, a way of operating as an artist, what is the future, what projects are you involved with at the moment and how do they relate to this body of work? Are there things that you'll continue to take forward? Will the preoccupations, with time, and with investigations revealing architecture as something animated and evolving, remain the same?

WW Yes. I am sure I will use this kind of artistic approach for future work, whereby I collaborate with industry, and with organisations within cities, in order to create something visible in public space and challenge perceptions of the urban environment in some way.

NP And this leads us back to where we began.

als *house-madrid* anstand, wusste ich genau, wie den technischen Problemen beizukommen war, und so entstand die Idee, das Filmmaterial als Galerieinstallation zu zeigen. Bei dem Event waren zwei Kameras an genau gegenüberliegenden Positionen angebracht, wobei mir vorschwebte, die so gedrehten Filme 1:1 und als Endlosschleife zu zeigen, die Zuschauer in der Mitte, so dass sie nicht beide Leinwände gleichzeitig anschauen können und somit zum Teil des Geschehens werden.

NP Die Filme plazieren die Zuschauer also mitten ins Geschehen, statt sie auf die Außenperspektive des Betrachters festzulegen?

WW So ist es. *House-birmingham* bot dann die Gelegenheit, diesen Ansatz noch einen Schritt weiterzuentwickeln, indem ich eine sich bewegende Kamera einsetzte. Ich wollte damit die Idee der Bewegung unterstreichen, die ja auf allen Ebenen der Projekte eine wichtige Rolle spielt. Die Kamera durchläuft während der gesamten Projektdauer von zwölf Tagen eine einmalige Kreisbewegung von genau 360 Grad um den Aufbau- und Abbauprozess und kommt also genau da zum Stillstand, wo sie ihre Umrundung begonnen hat. Dabei entsteht eine Endlosschleife mit ständig wechselndem Geschehen, wobei die langsame Kamerafahrt im Kontrast zu der rasenden Entwicklung der Baustellentätigkeit steht.

NP Ich halte das filmische Werk, das als Teil des Birmingham-Projekts entstand, in visueller Hinsicht für außerordentlich aussagekräftig. Die Tatsache, dass nicht mehr mit einer stationären, sondern mit einer das Baugeschehen umrundenden Kamera gedreht wird, lässt eine Horizontale einfließen, die mit der Vertikalität der wachsenden und schrumpfenden Wände lebhaft

house-city, 2003

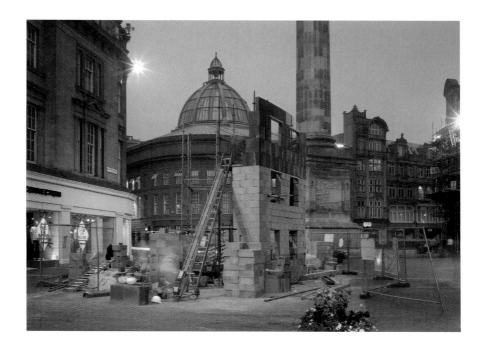

kontrastiert. Und dann ist da die Qualität des Lichts, das sich vom Tagesanbruch bis zum Dunkel-werden über den Platz spannt, Schatten wirft, die um den Rohbau wandern. Auch schafft die verwaschene Abbildung der hin- und hereilenden Bauarbeiter ein eindrucksvolles Geflecht von Bewegung inmitten der Wände. So entsteht eine hochkomplexe Matrix von allen möglichen Bewegungen, die Raum- und Zeitvektoren folgen.

WW Und da traf es sich wirklich gut, dass der gesamte Prozess zwölf Tage dauerte. Die Kreisfigur führt gewissermaßen auf unser Verständnis von Zeit und deren Einteilung in zwölf Einheiten zurück. Das Projekt ist wie eine monumentale Uhr.

NP Lass uns einen Blick in die Zukunft werfen. Zu Beginn unseres Interviews sagtest Du, mit den vier *house-projects* sei die Serie abgeschlossen. Hast Du bereits neue Arbeitsmethoden, künstleri-sche Ausdrucksmittel angedacht? Woran arbeitest Du zurzeit, und stehen diese Arbeiten mit den *house-projects* in einer Beziehung? Gibt es Anknüpfungspunkte, Fortentwicklungen? Wirst Du Dich weiterhin mit dem Thema Zeit und Deinen Erkundungen der Prozesshaftigkeit und Leben-digkeit von Architektur auseinandersetzen?

WW Ja. Ich bin sicher, diesen künstlerischen Ansatz auch in künftigen Arbeiten zu verfolgen. Ich werde auch weiterhin mit der Industrie und mit den Kommunen zusammenarbeiten, um etwas im öffentlichen Raum Sichtbares zu schaffen und unsere Wahrnehmungsmuster urbaner Umwelten zu hinterfragen.

NP Womit wir wieder am Anfang unseres Gesprächs angelangt wären.

house-city_3, 2003
Gelatin silver print
30 x 38 cm

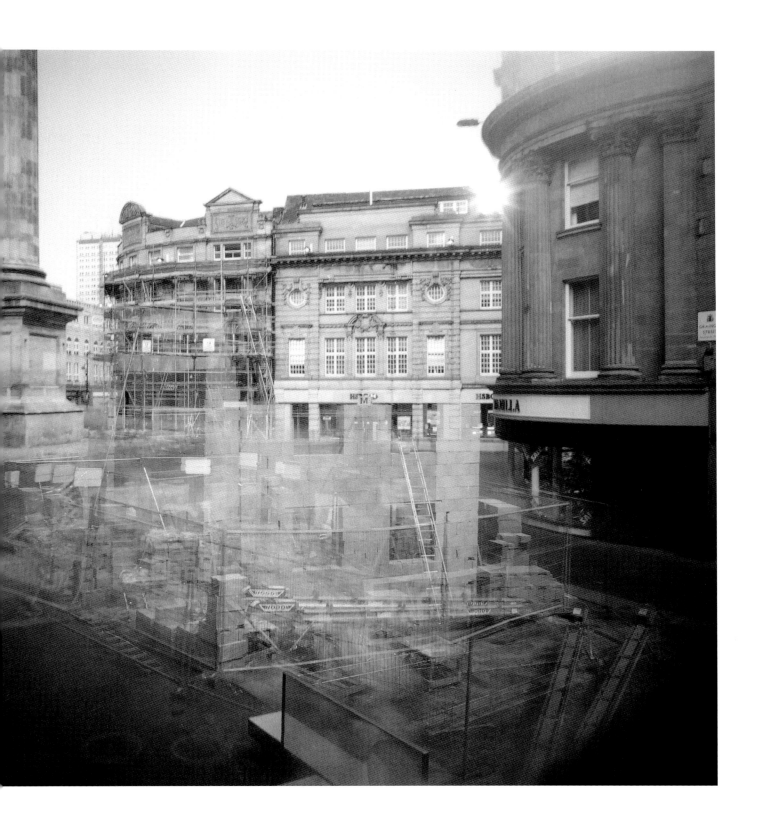

house-city_1, 2003
Gelatin silver print
67 x 110 cm

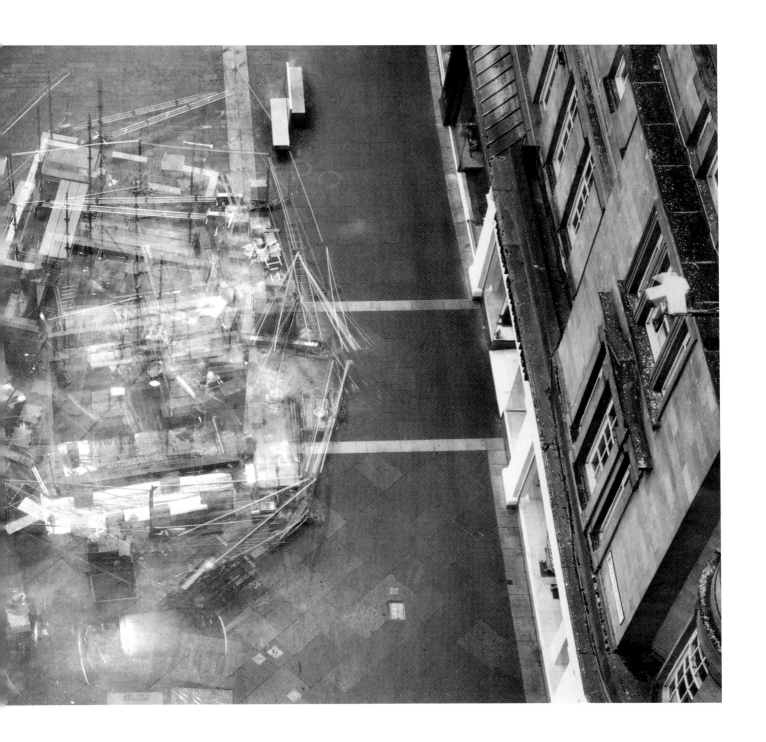

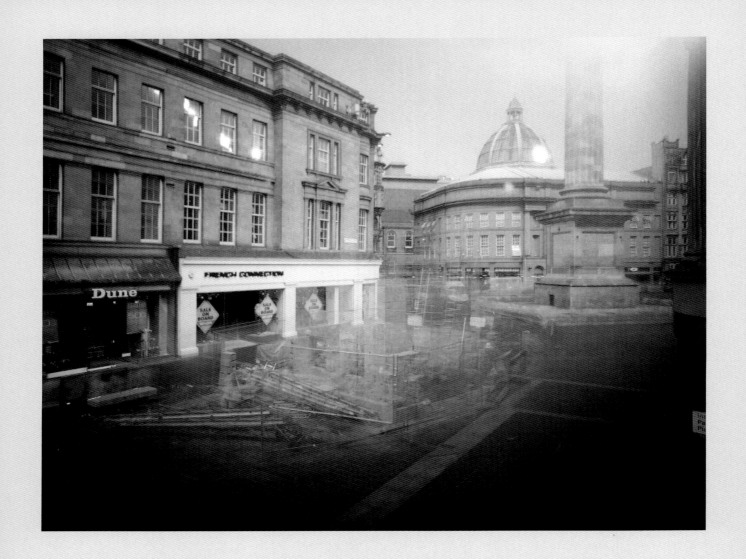

Sven-Olov Wallenstein

SCULPTURE, ARCHITECTURE, AND TIME:
NOTES ON THE WORK OF WOLFGANG WEILEDER

I

Architecture often appears as the very paradigm of permanence, stability, and order. Such determinations derive their authority from a tradition extending back to the very first text that attempted to theorise the art of building, i.e., Vitrivius's *Ten Books on Architecture* (and most likely even further back, although textual evidence for this is lacking). Vitruvius establishes the concept of *firmitas* in bringing together reflections on structural stability and building techniques with the sense of an over-arching cosmic order that is at once reflected and brought forth, mirrored and actualised, in the building, and this trope has been one of the founding ideas of architectural theory ever since. Architecture is a kind of knowledge that encompasses the information contained in the other arts, it is "encyclopedic," Vitruvius claims, "like a body composed of several limbs" that must be gathered together into the highest unity for the cosmic order to be achieved. The reasons for, and the metaphysical implications of, this stability have indeed undergone many changes since Antiquity, ranging from the cosmic and the theological, to different versions of 'nature,' 'reason,' and 'history,' but on one level the figure of thought has remained the same. The tectonic gesture, the "tecture" is what secures the "arche" by representing it, giving it a legible form.

BILDHAUEREI, ARCHITEKTUR UND ZEIT:
ANMERKUNGEN ZUM WERK WOLFGANG WEILEDERS

I

Architektur wird gern als Paradebeispiel für Dauerhaftigkeit, Stabilität und Ordnung angeführt. Solche Zuschreibungen werden mit einer Tradition autorisiert, die auf den ersten Text zurückreicht, der die Baukunst theoretisch zu fundieren trachtete. Gemeint ist Vitruvs in zehn Bücher gegliedertes Werk ›Über die Architektur‹. Wahrscheinlich reicht sie noch weiter zurück, doch mangelt es an entsprechenden Belegen. Vitruv entwickelte das Konzept von *firmitas*, indem er Überlegungen zur strukturellen Stabilität und zu Bautechniken mit der Vorstellung einer umgreifenden kosmischen Ordnung verband, die in einem Gebäude nicht nur reflektiert, sondern auch hervorgebracht, nicht nur gespiegelt, sondern auch verwirklicht wird. Seither gehört dieser Topos zu einer der Grundgedanken der Architekturtheorie. Architektur sei ein Wissen, in dem sich die Erkenntnisse sämtlicher anderer Künste versammeln, es sei, wie Vitruv behauptet, »enzyklopädisch«, »wie ein Körper, der aus mehreren Gliedmaßen zusammengesetzt ist« und müsse zu einer überragenden Einheit zusammengefügt werden, um der kosmischen Ordnung Genüge zu tun. Die Gründe für solche Stabilität und ihre metaphysischen Implikationen erfuhren seit der Antike manche Veränderung. Sie betrafen das gesamte Spektrum vom Kosmisch-Theologischen zu unterschiedlichen Konzepten von ›Natur‹, ›Verstand‹ und ›Geschichte‹, doch in einer Hinsicht ist

house-city_2, 2003
Gelatin silver print
30 x 38 cm

Now, for some historians this idea of a stability rooted in nature is precisely what is supposed to have disappeared at the beginning of the 19th century, thus a quest for new forms and orders opened up, that would eventually usher in what has become known as the "modern movement" with its visions of technology and constant change. But within the cycle of modern architecture the issue of stability and permanence became just as crucial as it was within the "classical" paradigm, and in a certain way one could say modernism was driven by the dialectic between those who wanted to achieve a new permanence and classicism – and Corbusier and Mies, each in their different way, could serve as paradigms for this – and those who dreamt of a new fluidity and transience, as in Sant' Elia's early visions of a *Città nuova* always caught up in state of flux. Although this second option seems mostly to have been relegated to the margins of architectural discourse, it always formed a strong undercurrent, perhaps even a disturbing one for those who wanted to consolidate modernism as a "new tradition"; we may even find both views co-existing in the same author, as in the case of Sigfried Giedion, the great propagandist and historian of the Modern Movement.

As a, or perhaps even *the* paradigm of permanence, architecture has always entertained a complex relation to time. On one hand, as an art of space it would seem to be precisely that which *resists* time; it is tied to the earth, it is heavy and bulky, and its gravitational pull resists the upward movement of the soul. Architecture, Hegel says, is the first spiritual shape in the hierarchy of art forms, and as such it is indeed the founding one, but one that has to give place – and time – for

die Denkfigur dieselbe geblieben. Es ist die tektonische Geste, die ›Tektur‹, die die ›Arche‹ birgt, da sie sie repräsentiert und eine lesbare Gestalt annehmen läßt.

Eine solchermaßen in der Natur wurzelnde Stabilitätsidee soll einigen Historikern zufolge zu Beginn des 19. Jahrhunderts in Vergessenheit geraten sein, was zu einer Suche nach neuen Formen und Ordnungen führte als Auftakt zu dem, was unter dem Namen »Moderne« mit ihrer Vision von Technologie und Wandlungspermanenz bekannt wurde. Doch in Kreisen moderner Architekten behaupteten Fragen von Stabilität und Dauerhaftigkeit die zentrale Rolle, die sie innerhalb des klassischen Paradigmas gespielt hatten. In gewissem Sinne lässt sich sogar sagen, daß der Modernismus beflügelt wurde durch die Dialektik zwischen jenen, die eine neue Dauerhaftigkeit und

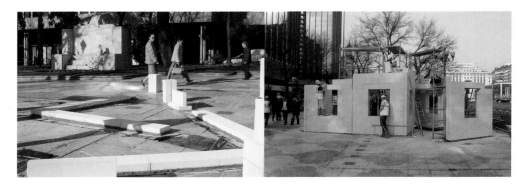

house-madrid, 2004

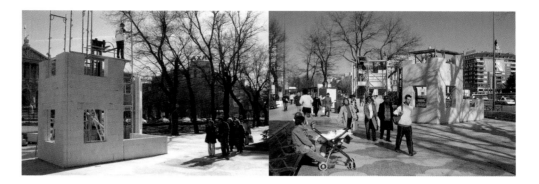

the subsequent form, (sculpture, painting, music, and poetry) to erect their hierarchy of increasing idealisation. But on the other hand architecture is that which, in resisting time but also by giving in to its ravages, *produces* human temporality, gives space to time as the possibility of memory and constancy. The pyramid, the temple, the cathedral, etc, are all forms which persist through history and thus allow for time to be organised as a legible sequence by forming its anchoring points. These forms may themselves fall into decay and become indexes of time, ruins and structures of accumulated pasts that occasionally acquire an even more striking presence than they had in their original state. (The strange temporality of *renovation* seems to be the obverse side of this: does renovation mean to restore an original, or merely to administer decay, or perhaps, as Viollet-le-

Klassizität erstrebten – Corbusier und Mies van der Rohe gehören auf ihre jeweilige Art dazu – und denen, die von einer neuen Vergänglichkeit und Wandelhaftigkeit träumten, wie Sant' Elia in seinen frühen Visionen einer *Città nuova*, die sich stets in einem transienten Zustand selbst überholt. Obwohl letztere Fraktion zumeist an den Rand des Architekturdiskurses gedrängt wurde, stellte sie doch stets eine starke, vielleicht sogar beunruhigende Unterströmung dar, zumindest für die, die den Modernismus als »neue Tradition« befestigen wollten; auch lassen sich beide Ansichten in ein und demselben Autor wiederfinden, wie z. B. im Falle von Sigfried Giedion, dem großen Propagandisten und Historiker der Moderne.

Die Architektur als ein, vielleicht sogar *das* Permanenzparadigma stand immer schon in einem komplexen Verhältnis zur Zeit. Als Kunst des Raums ist Architektur etwas, das der Zeit zu trotzen scheint; sie ist an die Erde gebunden, sie ist schwer und wuchtig, ihr Sog mit der Schwerkraft widersteht der Aufwärtsbewegung der Seele. Architektur, so Hegel, ist die erste geistige Gestalt in der Hierarchie der Künste, und als solche begründet sie diese und hat doch Platz – und Zeit – zu machen für die nachfolgenden Kunstformen (Skulptur, Malerei, Musik und Poesie) und so deren Rangfolge zunehmender Idealisierung zu errichten. Andererseits jedoch ist Architektur etwas, das menschliche Zeitlichkeit überhaupt erst hervorbringt, indem sie der Zeit trotzt, zugleich aber auch ihren Verwüstungen erliegt, der Zeit mithin einen Raum verschafft, in dem Gedächtnisstiftung und Kontinuität möglich werden. Die Pyramide, der Tempel, die Kathedrale etc., sie alle stellen Formen dar, die in der Geschichte fortdauern und so die Möglichkeit eröffnen, Zeit als Abfolge lesbar zu

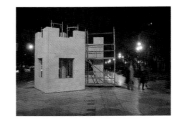

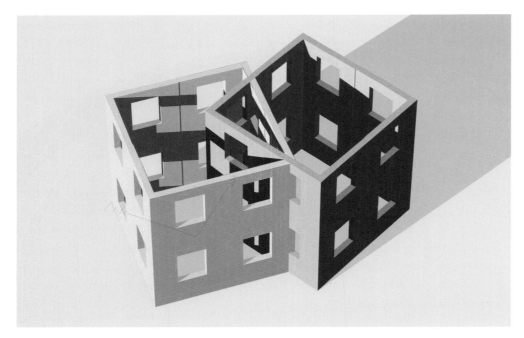

house-madrid, 2004
Computer generated
proposal sequence (detail)

Duc implied in the mid 19th century, to restore an original which was never there in the first place?) And finally, architecture is perhaps the form of art whose very construction involves time and extensive work to the largest extent, and where the division of labour is the most visible. These three modes of time all co-exist in architecture, and indicate the extent to which a division such as that between the arts of space and of time, or *die Künste des Nebeneinanders* and *die Künste des Nacheinanders*, to use Lessing's famous expression, can only be provisional.

II

In the *house-projects* of Wolfgang Weileder architectural and sculptural concerns intersect, and highlight, combine and dismantle all three temporal modes of building outlined above. In the four works realised so far, *house* (Newcastle upon Tyne, 2002), *house-city* (Newcastle upon Tyne, 2003), *house-madrid* (Madrid, 2004) and *house-birmingham* (Birmingham, 2004), the process of constructing becomes an essential part of the work itself. In all of them there are two teams working, engaging in a simultaneous process of "construction and deconstruction," as the artist writes. Two architectonic shells take form, interacting with each other in the (de)construction process, whose

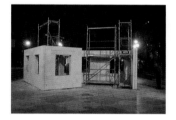 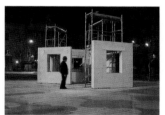 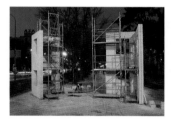 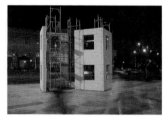

machen durch Formwerdung ihrer Ankerplätze. Solche Formen mögen ihrerseits dem Verfall anheimgegeben sein und zu Mahnmalen der Zeit werden, zu Ruinen, zu Massierungen von Vergangenheiten, denen mitunter eine eindrücklichere Präsenz eignet als den vom Zahn der Zeit noch unangetasteten, ursprünglichen Bauten. Die merkwürdige Zeitlichkeit der *Renovierung* scheint die Kehrseite der Medaille zu sein: bedeutet Renovierung die Wiederherstellung des Originals oder die schiere Verwaltung des Verfalls oder womöglich, wie Violet-le-Duc Mitte des 19. Jahrhunderts andeutete, die Wiederherstellung eines ursprünglich gedachten, vollkommenen Zustands, den es so nie gegeben hat? Und schließlich stellt Architektur vielleicht diejenige Kunstform dar, deren Erschaffung den größten Aufwand an Zeit und Arbeit voraussetzt und bei der Arbeitsteilung am sichtbarsten ist. Diese drei Zeitformen koexistieren in der Architektur und lassen erkennen, inwiefern eine Unterscheidung wie die zwischen Raumkünsten und Zeitkünsten, zwischen den *Künsten des Nebeneinanders* und den *Künsten des Nacheinanders*, um Lessings berühmte Formulierung zu zitieren, nur provisorischer Natur sein kann.

II

In Wolfgang Weileders *house-projects* treffen architektonische und bildhauerische Anliegen aufeinander, mit dem Ergebnis, dass sie die soeben skizzierten Zeitmodalitäten des Bauens betonen,

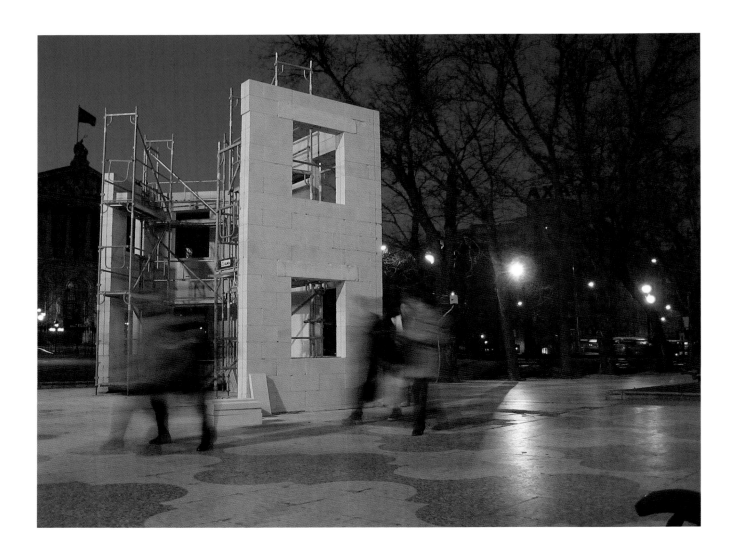

house-madrid, 2004

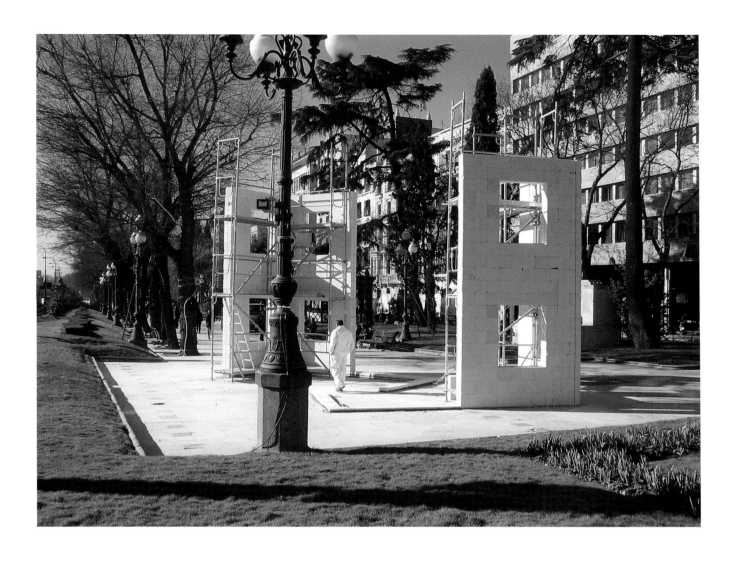

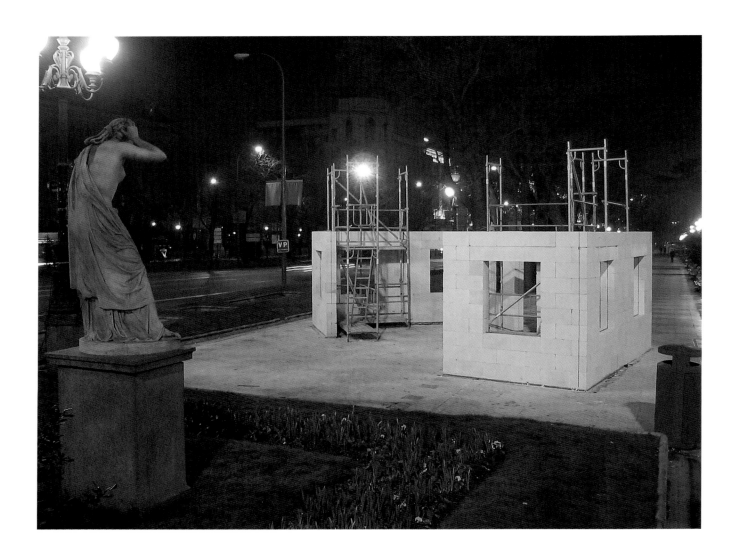

house-madrid, 2004

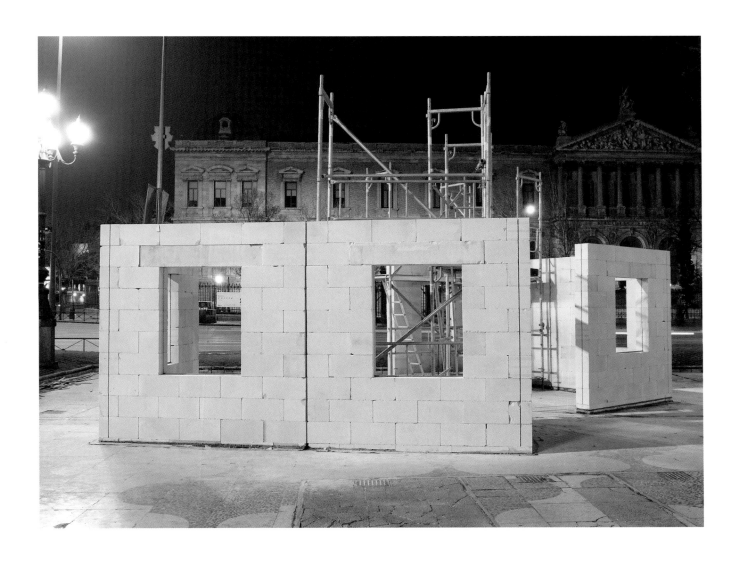

temporal stretch has varied from 22 hours up to twelve days. Architecture is set in motion, walls move around, and the idea of tectonics becomes unstable as the process of work and construction itself become visible. The making and unmaking itself becomes an event, whereby we encounter not just a finished product, but all of the preceding stages that eventually disappear into the classical architectural object.

This temporal overlay implies that it is only in the documentation, consisting of video and photography, that we can have full access to the work. The videos show the complete projects at high speed, whereas the photographic plates are exposed throughout the entire construction process, resulting in multi-layered images that record the different stages, overlaid on each other in a spectral simultaneity, as if there were no proper way to experience these works without acknowledging the passage of time within the image itself. Analogous to the two construction teams, the images synthesise by assembling the process into a visible whole, and analyse by tearing different layers apart so as to create a constantly shifting object that can not be located at any precise point in time. It is simply never just absent or present; the work is neither finished nor unfinished, but maybe in the process of *becoming unfinished*.

A recurring trait in these structures is the gradual intersection, rotation, collision, and interaction of two parts. On the formal level of drawings and plans they display a certain resemblance to the earlier works in Peter Eisenman's proto-deconstructive *House* series (1967–1979), which attempted to explore the possibilities inherent in the manipulation of simple geometric form. Eisenman's

verbinden und auflösen. In den vier bislang fertig gestellten Arbeiten, *house* (Newcastle upon Tyne, 2002), *house-city* (Newcastle upon Tyne, 2003), *house-madrid* (Madrid, 2004) und *house-birmingham* (Birmingham, 2004) wird die Bauphase zu einem wesentlichen Bestandteil des Werks. In allen genannten Projekten arbeiten jeweils zwei Teams, die, so der Künstler, in einen Prozess gleichzeitiger »Konstruktion und Dekonstruktion« eintreten. Zwei architektonische Rohbauten nehmen in dem (De-)Konstruktionsprozess, dessen Dauer zwischen 22 Stunden und zwölf Tagen schwankte, Gestalt an und interagieren miteinander. Architektur wird so in Bewegung gesetzt, Wände werden versetzt, die Vorstellung von Tektonik gerät in dem Maße ins Wanken, in dem Arbeits- und Bauprozess selbst sichtbar werden. Das Machen und Rückgängig-Machen wird an sich schon zum Ereignis, so dass wir nicht nur einem fertigen Ergebnis gegenüberstehen, sondern sämtlichen vorlaufenden Schritten, die traditioneller Weise in ein architektonisches Objekt münden und darin aufgehen.

Diese zeitliche Überlagerung bringt es mit sich, dass wir nur über die per Video und Fotographie verfügbare Dokumentation einen vollständigen Zugang zum jeweiligen Werk finden. Die Videos zeigen die gesamte Projektdauer im Schnelldurchlauf, während die fotographischen Platten während der gesamten Projektdauer belichtet werden, so dass vielschichtige Bilder entstehen, die die unterschiedlichen Bauphasen wiedergeben, Schicht um Schicht in einer spektralen Gleichzeitigkeit, als könne man diese Werke nicht gebührend auf sich wirken lassen, ohne das Verstreichen der Zeit in dem Bild selbst zu würdigen. Analog zu den beiden Bauteams setzen auch die Bilder

house-madrid, 2004

drawings and models (and in some cases executed buildings) sought to uncover a certain radical purity of the architectural sign, that for him could only be attained by displacing all traditional notions of form, function, use, etc, i.e., by neutralising or reducing the semantics of architecture – "dislocating the metaphysics of architecture," as Eisenman stated. In many ways this brought him close to issues in both minimalist and conceptual art, especially Sol LeWitt, in that the new architecture, just as the new sculpture, had to be understood as a physical presence directly referring to itself, without being mediated by any representation of 'meaning.' But there was also a decisive difference, since Eisenman, unlike many of the post-minimalist sculptors, wanted to break away from the phenomenological model and its emphasis on the body as a source of meaning, and opted for model based on linguistics and syntax. Weileder's sculptural and architectural interventions at once situate themselves in the midst of this exchange, but in their emphasis on process and time, and on the actual means of construction, provide a new perspective on these issues. This is especially true in their addressing of social space and the way in which the temporary building process occur in the midst of the city.

etwas zusammen, da sie den gesamten Prozess in eine sichtbare Gleichzeitigkeit bündeln. Sie zerlegen aber auch, indem sie die verschiedenen Bildschichten fragmentieren und ein in stetiger Veränderung begriffenes Objekt erzeugen, dessen Raumkoordinaten sich nicht präzisen Zeitkoordinaten zuordnen lassen. Es ist mit anderen Worten weder anwesend noch abwesend; das Werk ist weder vollendet noch unvollendet, allenfalls im Begriff, *unvollendet zu werden*. Ein immer wiederkehrendes Merkmal in diesen Strukturen ist die sukzessive Überschneidung, Drehung, Kollision und Interaktion zweier Teile. Auf der formalen Ebene der Zeichnungen und Konstruktionspläne weisen sie gewisse Ähnlichkeiten mit den frühen proto-dekonstruktivistischen *House*-Serien (1967–1979) auf, in denen Peter Eisenman die Möglichkeiten der Manipulation einfacher geometrischer Formen auslotete. Eisenmans Zeichnungen und Modellbauten (und in einigen Fällen auch ausgeführte Bauten) suchten eine bestimmte radikale Reinheit des architektonischen Zeichens freizulegen, was sich seiner Meinung nach nur bewerkstelligen ließ, wenn man sich von allen traditionellen Begriffen von Form, Funktion, Gebrauch etc. lossagte, d. h. durch Neutralisierung und Reduzierung der Semantik der Architektur – »die Metaphysik der Architektur aus den Angeln heben«, wie Eisenman es nannte. Das brachte ihn in mancher Hinsicht auf Fragestellungen, denen sowohl die minimalistische wie auch die konzeptuelle Kunst nachging, vor allem Sol LeWitt, da die neue Architektur wie die neue Bildhauerei als körperliche Präsenz zu verstehen war, die unmittelbar auf sich selbst verwies, statt vermittelt zu werden durch die Repräsentation einer wie auch immer gearteten »Bedeutung«. Doch gab es auch einen entscheidenden Unterschied, da sich

Since the beginnings of Minimal Art and its morphological and phenomenological investigations of the very meaning of the object, and of the limits between object and environment, visual art has indeed taken up a highly complex dialogue with architecture and urbanism that has profoundly challenged traditional notions of space and place. Painting and sculpture, that for a long time had divided up the field of art between themselves in terms of a distinction between two- and three-dimensionality, the 'optical' and 'haptic,' suddenly ceased to appear as self-evident categories, and a new type of environmental contextualisation of the art object became a decisive strategic problem. In these debates from the mid '60s, we can see the emergence of the category 'object,' that was something more inclusive than painting or sculpture. Further, 'environment' or 'installation' – whose sense was gradually displaced from the simple installing of art works to a new type of assembling of things that come together to form a work – became concepts that expressed this expansive outward movement into space, both physical and social, where the kind of concerns and questions that had previously been the terrain of architecture and urbanism took on a new importance for artists. The new emphasis in the work of artists like Judd and Morris on the physicality of the work and the way it partakes in the same setting as the body of the beholder opened up new spatial issues, where all parameters had to be taken into account, and where the limit between inner and outer, text and context, was always a conscious choice and an element in the work itself. It was as an obvious consequence of this that the architectural domain, as a place for spatial articulation of bodily trajectories and patterns of perception, became the

Eisenman im Gegensatz zu vielen post-minimalistischen Bildhauern vom phänomenologischen Modell und seiner Betonung des Körpers als Bedeutungsquelle lösen wollte und sich stattdessen für ein Modell entschied, das auf Sprache und Syntax basierte. Weileders bildhauerische und architektonische Interventionen sind mitten in diesem Diskurs angesiedelt, eröffnen jedoch mit ihrer Betonung des Prozeßhaften, der Zeitabhängigkeit und der tatsächlich verwendeten Bauwerkzeuge neue Sichtweisen. Dies gilt insbesondere für die Thematisierung des sozialen Raums und der Art und Weise, wie sich der zeitgenössische Bauprozess inmitten der Stadt vollzieht. Seit den Anfängen der Minimal Art und ihrer morphologischen und phänomenologischen Untersuchung der eigentlichen Bedeutung des Objekts und der Grenzen zwischen Objekt und Umwelt stehen die Bildende Kunst, die Architektur sowie die Stadtplanung in der Tat in einem hochkomplexen Dialog, der die traditionellen Vorstellungen von Raum und Ort von Grund auf erschüttert hat. Nachdem Malerei und Bildhauerei lange Zeit das Feld der Kunst entlang der Wasserscheide zwischen Zwei- und Dreidimensionalität, zwischen dem ›Optischen‹ und dem ›Haptischen‹, unter sich aufgeteilt hatten, boten sie sich plötzlich nicht mehr als vermeintlich selbstverständliche Kategorien an. Eine neue Art umweltsensitiver Kontextualisierung des Kunstobjekts wurde zum entscheidenden strategischen Problem. Aus solchen Debatten der 60er Jahre ging die Kategorie ›Objekt‹ hervor, womit mehr gemeint ist als Malerei oder Bildhauerei. Ferner entwickelten sich ›Umwelt‹ und ›Installation‹ – wobei sich das Verständnis des letzteren Begriffs von der simplen Anbringung eines Kunstwerks zu einer neuen Form der Zusammenstellung von Dingen zu einem

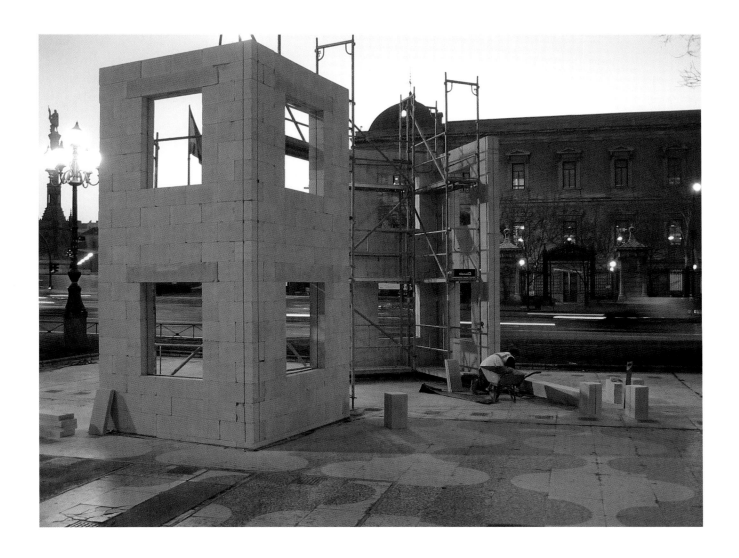

house-madrid, 2004
Computer generated
proposal sequence (detail)

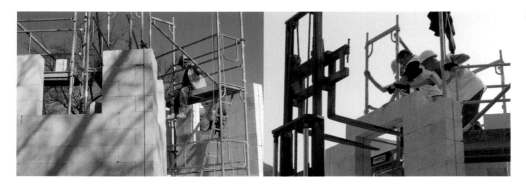

testing ground for artistic interventions of the most diverse nature. This can be seen in the spectacular actions of Gordon Matta-Clark's house intersections and cuts, Robert Smithson's highlighting of the entropic dimension that always undermines all claims to permanence, and in the subtle manipulations of the linguistic and visual codes of our built environments evident in Dan Graham's text-image works and architectural models.

These types of interventions were often seen as having a fundamentally negative value, in the sense that they would disrupt architecture as a model of authority, technological perfection, and capitalism. With hindsight, they come across more as attempts to open up architecture, to investigate its different layers of sense, and to chart a new territory for artistic activity. What

Kunstwerk wandelte – zu Konzepten, die jenem expansiven Drang in den Raum hinein Ausdruck gaben, in physischem wie sozialen Sinne, wobei die Probleme und Fragestellungen, die vormals das Terrain der Architektur und Städteplanung ausmachten, neue Bedeutung für Künstler gewannen. Die im Werk von Künstlern wie Judd und Morris sichtbare neue Akzentuierung der Körperlichkeit des Werks und seiner Teilhabe an demselben Milieu, dem auch der Körper des Betrachters angehört, öffnete neue Raumthemen, bei denen alle Parameter berücksichtigt werden wollten und bei denen die Grenze zwischen Innen und Außen, Text und Kontext immer das Ergebnis einer bewußten Wahl und mithin Bestandteil des Werkes selber war. Es konnte nicht ausbleiben, daß die architektonische Domäne als Ort für Raumartikulationen von körperlichen Bewegungsabläufen und Wahrnehmungsmustern zum Testgelände für künstlerische Interventionen der unterschiedlichsten Art wurde. Man denke an die spektakulären Aktionen von Gordon Matta-Clarks Häuserschnitten, Robert Smithons Hervorhebung der entropischen Dimension, die sämtliche Ansprüche auf Dauerhaftigkeit konterkariert, oder an die subtilen Manipulationen der linguistischen und visuellen Codes unserer gebauten Umwelten, wie sie in Dan Grahams Text-Bild-Arbeiten und architektonischen Modellen sichtbar werden. Solche Interventionen wurden häufig als grundsätzlich negativ bewertet, insofern sie einer Architektur, die die Gußform von Autorität, technologischer Perfektion und Kapitalismus sein will, ein Ende bereiten. Im nachhinein wirken sie eher wie Versuche, die Architektur zu öffnen, ihre unterschiedlichen Bedeutungsebenen zu erkunden und Neuland für künstlerische Betätigung zu erschließen. Was uns heute interessiert, ist nicht

interests us today is not the violence of these works, but rather their quality as explorations and mappings, as new ways to experience space – especially so if we look back on them from today's vantage point, where the architecture and urbanism provide artists with a new set of tools, as in the case of Weileder's *house-projects*. They explore the three-fold temporality of architecture – its permanence and resistance to time as decay; its eventual decomposition and surrender to the time inherent in the production of memory; and its resurrection through renovation in both still and moving images. It is these that form something like complex crystals of time, although now without any sense of architecture as that which represses and encloses. Quite simply they allow us to perceive *more* in what we thought of as mere brick and mortar, to see the *more* of the movement, spatial as well as temporal, inherent in all that we have thought of as *firmitas*.

SVEN-OLOV WALLENSTEIN teaches philosophy at the University College of Södertörn, and architectural theory at the Royal Institute of Technology, both in Stockholm, and is the editor in chief of SITE. He is the translator of works by, among others, Kant, Hegel, Frege, Husserl, Heidegger, Levinas, Derrida, Deleuze and Agamben, and has published many essays and books on contemporary philosophy, aesthetic theory, visual arts, and architecture. Among his recent publications are *Bildstrider* (*Image Wars*, 2001), *Den sista bilden: det moderna måleriets kriser och förvandlingar* (*The Last Image: Crises and Transformations of Modernist Painting*, 2002), and *Den moderna arkitekturens filosofier* (*The Philosophies of Modern Architecture*, 2004).

die Gewalt in diesen Werken, sondern ihr Wesensmerkmal, Expedition zu sein, Vermessung, ein neuartiger Wegweiser, Raum zu erfahren – besonders dann, wenn wir sie von heutiger Warte aus betrachten, wo Architektur und Städteplanung, wie im Falle von Weileders *house-projects*, Künstlern ein neues Instrumentarium an die Hand gibt. Sie erkunden die dreifache Zeitlichkeit von Architektur – ihre Dauerhaftigkeit und Widerständigkeit gegenüber der Zeit, der Kraft des Verfalls; ihre schlussendliche Auflösung und Kapitulierung gegenüber der Zeit, wie sie der Gedächtnisstiftung innewohnt; und ihre Wiederauferstehung durch Erneuerung in ruhenden und bewegten Bildern: Letztere formen komplexe Zeitkristalle, in denen Architektur als etwas Umschließendes und Einengendes nicht länger sichtbar ist. Mit anderen Worten, sie erlauben uns, ein Mehr an dem wahrzunehmen, was wir für Ziegel und Mörtel hielten, ein Mehr an räumlicher wie zeitlicher Bewegung zu sehen, die zu allem gehört, was wir ehedem für *firmitas* hielten.

SVEN-OLOV WALLENSTEIN lehrt Philosophie am University College of Södertön und Architekturtheorie am Royal Institute of Technology in Stockholm. Er ist Chefredakteur der Zeitschrift SITE, Übersetzer von Werken von Kant, Hegel, Frege, Husserl, Heidegger, Levinas, Derrida, Deleuze und Agamben u. a. und Verfasser zahlreicher Aufsätze und Bücher zur zeitgenössischen Philosophie, Kunsttheorie, Bildenden Kunst und Architektur. Zu seinen jüngsten Veröffentlichungen zählen *Bildstrider* (*Bilderstreiten*, 2001), *Den sista bilden: det moderna måleriets kriser och förvandlingar* (*Das letzte Bild: Krisen und Verwandlungen der modernen Malerei*, 2002) und *Den moderna arkitekturens filosofier* (*Die Philosophien der modernen Architektur*, 2004).

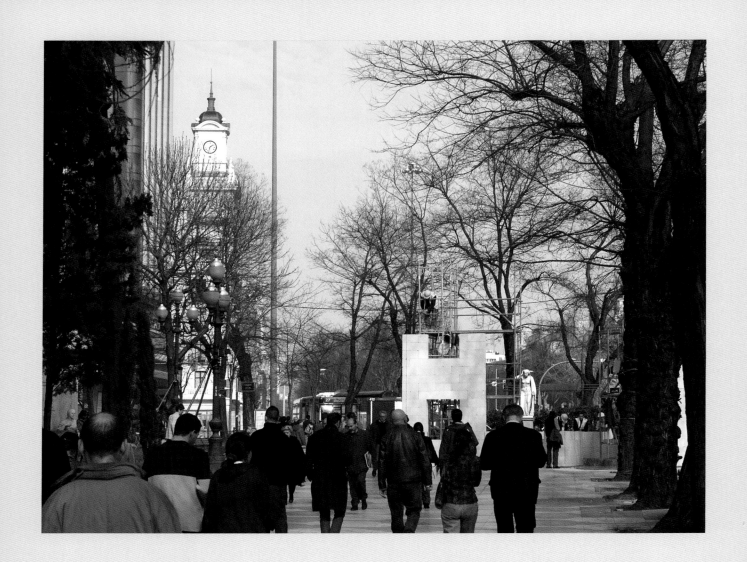

Lisa Le Feuvre

EVENT ARCHITECTURE

Wolfgang Weileder's *house-projects* move across definitions of event, intervention, temporary object, film and photography, whilst operating in the indefinable space of rumour and memory. This series uses a grammatical structure based on the processes involved in each artwork, as well as the continuity and self-reflexivity within the series as a whole. In each instance Weileder shifts architecture from a passive, or object, status into a realm of duration and dynamism. Writing on the changing concepts of time and space that took place at the turn of the 19th Century, Sanford Kwinter[1] discusses how the Futurists set out to create a 'new' art that would systematically express and reflect contemporaneity within painting, sculpture and architecture. In this period inventions (such as the elevator), innovations in travel and revolutionary developments in physics radically shifted perceptions of surrounding contexts and environments, ushering in a move from a spatial to temporal conceptions of the world. The Futurists insisted that museums, libraries, acts of contemplation, history, old age and stasis in *any* form should be overthrown by a new aesthetics built on speed and motion, with artistic techniques and subject matter drawn from the concrete contemporary world. Umberto Boccioni, in his *Technical Manifesto of Futurist Sculpture*, explained how the perception of objects required the surrounding, negative, space to be taken into account. He considered the areas between objects as "not empty spaces but rather continuing materials of differing intensities which [Futurist artists and architects] reveal with visible lines which do not

EVENT ARCHITEKTUR

Wolfgang Weileders *house-projects* überschreiten die kategorischen Grenzen zwischen Event, Intervention, temporärem Objekt, Film und Fotografie und operieren im übrigen im undefinierbaren Raum des Gerüchts und der Erinnerung. Seine Projektserie bedient sich einer grammatikalischen Struktur, die auf den Herstellungsprozess rekurriert, der jedem Kunstwerk eigen ist, sowie auf die Laufzeit und internen Verweisungszusammenhänge der Serie insgesamt. In seinen Projekten stellt Weileder den passiven, objekthaften Status der Architektur in Frage und siedelt sie im Zeitterrain von Dauer und Dynamik an.

In seinem Buchkapitel über sich wandelnde Zeit- und Raumkonzepte zu Beginn des 20. Jahrhunderts schildert Sanford Kwinter, wie die Futuristen antraten, eine ›neue‹ Kunst zu schaffen, die die Zeitgenossenschaft von Malerei, Bildhauerei und Architektur systematisch zum Ausdruck brachte und reflektierte.[1] Unter dem Einfluss technischer Erfindungen (wie z. B. des Aufzugs), Innovationen im Bereich des Transportwesens und revolutionärer Entwicklungen in der Physik wandelte sich in jener Zeit die Wahrnehmung von Kontexten und Umwelten radikal, womit die allmähliche Ablösung räumlicher durch zeitliche Weltverständnisse eingeläutet war. Mit einer neuen Ästhetik, die auf Geschwindigkeit und Beweglichkeit setzte, sagten die Futuristen Museen, Bibliotheken, gedankenschwerer Unbeweglichkeit, der Geschichte, dem Alter und jeder Form von Stillstand den Kampf an, wobei künstlerische Techniken und Themen künftig der konkreten, aktuellen Alltags-

correspond to any photographic truth", defining space as two interpenetrating fields where "absolute motion is a dynamic law grounded in an object." The, contradictory, belief of movement fixed in an object is concerned with the ways in which the contingencies of perception form understandings of space in relation to time and experience.

These factors are central to Weileder's *house-projects*. Each work ostensibly takes the form of a doubled architectural design where, over a specific time period, two shells are simultaneously built and unbuilt in a circular flow. The constructions rise into 'un-buildings' as the limited supply of building materials is recycled in a process of constant movement. Recordings, in film and photography as well as the more intangible anecdotal evidence of first-hand experience and its retelling, extend the one-off event into the future. The first work in the series, *house* (2002), took place within the School of Arts and Cultures at the University of Newcastle. Designed to fit within the restrictions of the interior space hosting the project, and adhering to strict and standard building regulations, a structure based on the two-up-two-down layout of a typical Victorian terraced house – a style common to the area – was constructed and un-constructed over a period of twenty four hours. Five pinhole cameras recorded the event. A pinhole camera is the simplest camera possible, working on the principle of light transmitting an inverted and reversed image, thus transferring every point of a scene or view on to the available surface. A small hole acts as a lens and through this aperture light is forced to represent what can be 'seen', effectively creating a direct representation that is dependent on time. Early photography was often referred

welt entnommen werden sollten. Umberto Boccioni erläuterte in seinem *Technischen Manifest futuristischer Bildhauerei*, wie die Wahrnehmung von Objekten von der Wahrnehmung ihrer Umgebung, ihres Negativs, ihres Raums abhing. Er betrachtete die Areale zwischen Objekten »nicht als leeren Raum, sondern vielmehr als Raumfortsetzungen von Materialien unterschiedlicher Intensität, die [futuristische Künstler und Architekten] mit sichtbaren Linien zum Vorschein bringen, auch wenn sie keineswegs mit der fotografischen Wahrheit übereinstimmen«. Damit definierte er den Raum als zwei sich wechselseitig durchdringende Bereiche, in denen »die absolute Bewegung das in einem Objekt erdgebundene dynamische Gesetz ist«. Dem stand die Überzeugung entgegen, Bewegung werde in einem Objekt fixiert, bei der es um Arten und Weisen geht, in denen Wahrnehmungszufälle das Verständnis von Raum im Verhältnis zu Zeit und Erfahrung formen.

Solche Einflüsse sind in Wolfgang Weileders *house-projects* deutlich erkennbar. Jedes seiner Werke nimmt vordergründig die Form eines verdoppelten architektonischen Designs an, wobei über einen festgelegten Zeitraum in einem rhythmischen Zyklus zwei Rohbauten gleichzeitig gebaut und wieder abgebaut werden. Aus den Montagen entstehen Demontagen, indem die vorhandenen Baumaterialien in einem kontinuierlichen Fluss immer wieder aufs neue verwendet werden. Filmische und fotografische Aufnahmen wie auch die schwerer zu greifenden anekdotischen Belege derer, die dabei waren, und das wiederholte Weitererzählen solcher Augenzeugenberichte verlängern das einmalige Event in die Zukunft. Das erste Werk der Serie mit dem Titel *house* (2002) ereignete sich an der School of Arts and Cultures an der University of Newcastle. Über einen

to as "the pencil of nature": a phrase used in the title of William Henry Fox Talbot's publication series, *The Pencil of Nature*, which set out to show the possibilities of photography. The medium was regarded as possessing the ability to provide a direct and unmediated transcription of reality that became perceived as incontrovertible evidence. Photography of course is not a mirror, it is something that produces effects through its powers: far from 'magical', it is a contingent and temporal medium.

Following this first artwork-event in the series, Weileder conducted ensuing episodes of *house-projects* (*house-city*, 2003; *house-madrid*, 2004; *house-birmingham*, 2004) outside of a hosting architectural structure; interjecting stumbling blocks into public circulation spaces to re-articulate the experience and perception of urban space. *House-city* took place in a busy intersection within the pedestrianised central shopping area of Newcastle over six days. The insertion of a new construction within a built-up area initiated debate amongst some occupants of the city (veering from outrage at the perceived act of increased urbanisation in spite of building regulations, to a desire to possess and occupy the construction), while others simply walked by, gently avoiding an annoying construction that impeded movement just as one might step aside road works. Cameras were placed at street and panoramic level, imprinting the forward and reverse progress of building. Engagement with the *house-projects* requires the impossible experience of experiencing space over time to an extent that *exceeds* possible interaction. Photography, however, makes this possible; Weileder stretches the use of the medium from an instant reflection of a particular moment to an

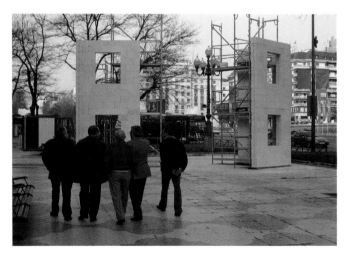

house-madrid, 2004

Zeitraum von 24 Stunden wurde ein auf das Innere des Raums, in dem das Event stattfand, abgestimmter Bau konstruiert und dekonstruiert, der der Bauart eines für diese Gegend typischen viktorianischen Reihenhauses nachempfunden war. Fünf Lochkameras nahmen das Event auf. Eine Lochkamera ist eine denkbar einfache Kamera, die auf dem Prinzip beruht, dass Licht ein seiten- und höhenverkehrtes Bild übermittelt und so jeden Punkt eines Schauplatzes oder einer Aussicht auf die verfügbare Filmebene überträgt. Durch ein kleines Loch, das als Linse dient, fällt Licht ein und bildet das ab, was man ›sieht‹, wodurch es tatsächlich zu einer Abbildung kommt, die zeitabhängig ist. In den Anfängen der Fotografie sprach man gern vom »Zeichenstift der Natur«, eine Formulierung, die William Henry Fox Talbot als Titel für seine den Möglichkeiten der Fotografie gewidmete Veröffentlichungsreihe *The Pencil of Nature* verwendete. Mit dem Medium Fotografie glaubte man, eine unmittelbare und unvermittelte Abschrift der Wirklichkeit produzieren zu können, die man schon bald für einen unwiderlegbaren Beleg hielt. Zwischen einer Fotografie und einem Spiegel besteht indes noch ein Unterschied. Die Fotografie kreiert Effekte: Weit davon entfernt, ›magisch‹ zu sein, stellt sie ein bedingtes und zeitabhängiges Medium dar.

extended occurrence. Photography is a form of communication that, like language, relies on established codes and references relating to systems of representation. Weileder converses with these systems of understanding in a defiantly un-photographic way.

These photographs reveal the *process-of-building* rather than the *building-as-object*, privileging the still image as an active document over static documentation. In each of the *house-projects* custom-made cameras create both still and moving images using analogue – so unmanipulated – technologies. Using long exposures each frame of movement is fixed on film. In *house-madrid* the construction/unconstruction took place over ten days, with the photographs impossibly showing lit streetlamps in daylight whilst the sun can be seen setting behind the rooftops on one side and rising above the buildings in the other. Scaffolding poles used in the construction become visible at successive moments of rest, thus appearing to be in motion. Not about place, *house-projects* is concerned with time: each construction is designed in relation to its particular site, but the locality is simply an armature with these 'false-architectures' possessing a potential to take place anywhere. The descriptive photographs have a literal correspondence point-by-point to nature, yet what is revealed cannot be seen with the eye. Eugene Atget's early photography of Paris captured the city eerily unpopulated, save for the odd ghost-like trace of a moving individual who was too fleeting for the technologically necessary long exposures to fix in place. Similarly, Weileder's spaces are empty of people, yet vehicle headlights flow along roadways as if specks of dust. Tonally the different elements of the representations of Weileder's architecture vary as the camera provides a

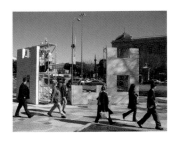

house-madrid, 2004

Auf dieses erste Event folgten unter Weileders Federführung weitere Häuserprojekte (*house-city*, 2003; *house-madrid*, 2004; *house-birmingham*, 2004), die jedoch im Freien außerhalb einer bereits vorhandenen architektonischen Struktur durchgeführt und gewissermaßen als Stolpersteine auf öffentliche, stark frequentierte Plätze gestreut wurden, mit dem Ziel, die Erfahrung und Wahrnehmung städtischer Räume ins Bewusstsein zu heben. *house-city* fand an einer belebten Kreuzung in der Fußgängerzone von Newcastle statt und dauerte sechs Tage. Die Einbringung eines neuen Baukörpers in ein dicht bebautes Gebiet provozierte einige Bewohner der Stadt zu Reaktionen, die von Empörung angesichts des scheinbaren Aktes verstärkter Urbanisierung trotz behördlicher Bebauungsgesetze bis hin zu dem Wunsch reichten, das Bauwerk zu besitzen oder zu besetzen. Andere gingen einfach vorüber, wobei sie die ärgerliche Konstruktion geflissentlich umschifften, ganz so, als wichen sie einer Baustelle aus. Kameras waren auf Straßen- und Panoramaniveau aufgestellt und zeichneten den Fort- und Rückschritt im Bauprozess auf.

Eine adäquate Beschäftigung mit den *house-projects* erfordert eigentlich die Möglichkeit der unmittelbaren Raumerfahrung und der Interaktion mit dem Raum. Dies ist aber nur für den Zeitraum des Events möglich, danach können nur noch Fotos diese Erfahrung vermitteln. Weileder gebraucht das Medium der Fotografie nicht, um einen bestimmten *Moment* festzuhalten, sondern um ein *Langzeit*geschehen zu dokumentieren. Fotografie stellt eine Kommunikationsform dar, die ähnlich wie Sprache auf die herrschenden kulturellen Codes und Bezugssysteme vertraut, die sich auf Darstellung beziehen. Weileder hält Zwiesprache mit

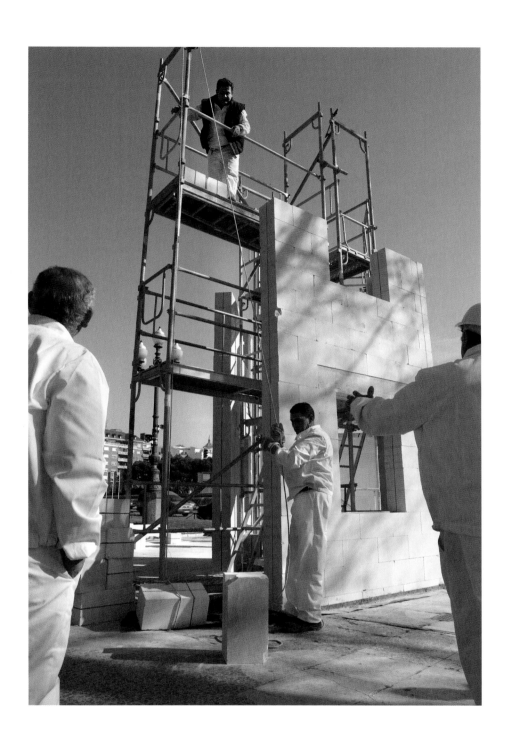

house-madrid_3, 2004
Gelatin silver print
79 x 100 cm

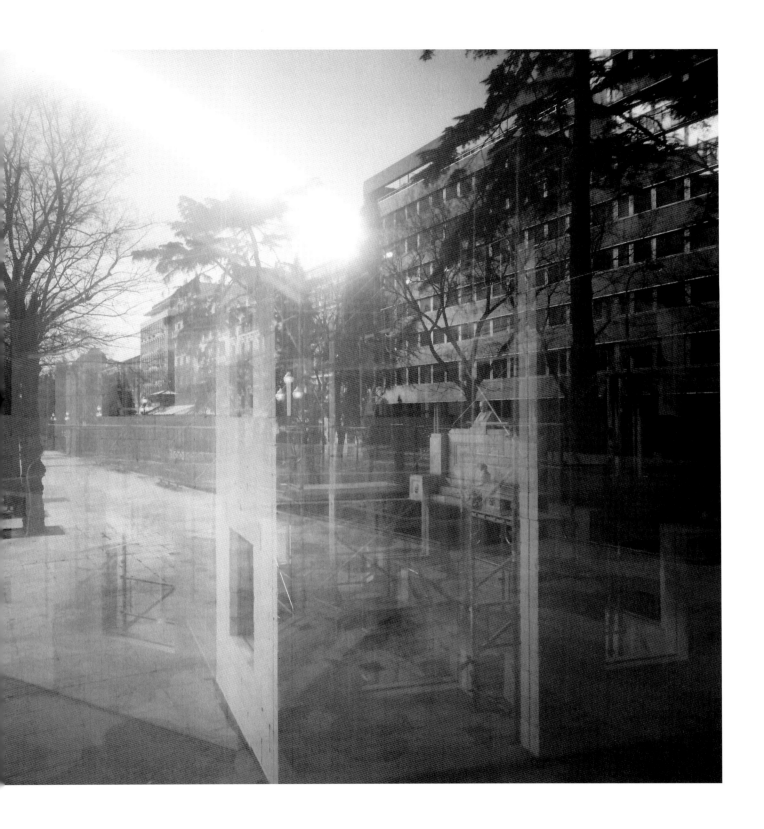

house-madrid_2, 2004
Gelatin silver print
79 x 100 cm

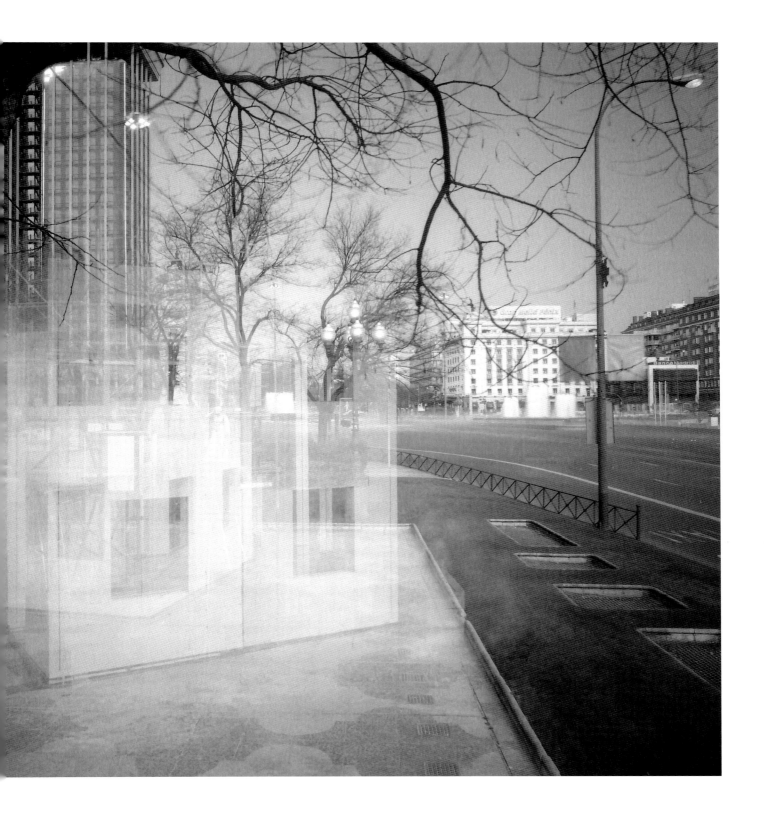

house-madrid_4, 2004
Gelatin silver print
79 x 100 cm

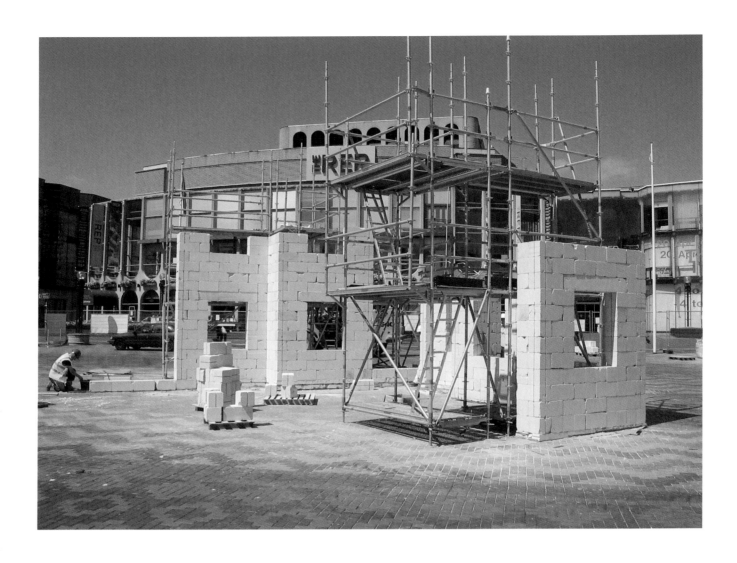

house-birmingham, 2004

stronger and sharper trace of the parts that exist over a long duration, such as the lower lines of masonry as opposed to the uppermost sections of scaffolding that appear as pencil-drawn shadows. One of the key roles of photography is to reveal 'I have been there': to provide incontrovertible evidence of an event. To use a photograph to point to Weileder's now non-existent interventions creates a complication of the shifting relationship between signifiers and signifieds.

Writing on tendencies within artistic production in the early 1970s, Rosalind Krauss discusses in *Notes on the Index*[2] the ways in which she observes artists engaging with the indexical languages of photography within more sculptural and interventionist practices. She describes the photograph as a system that directly represents the presence of something by its absence, enabling the photograph to become an equivalent to an object or event that no longer can be experienced. Quoting the semiotician Charles Sanders Pierce, Krauss describes how: "Photographs, especially instantaneous photographs, are very instructive, because we know they are in certain respects exactly like the objects they represent. But this resemblance is due to the photographs having been produced under such circumstances that they were physically forced to correspond point by point to nature." The photograph is always a representation of *something*, acting – in semiotic terms – like a 'shifter' in its reliance for definition on the event or object to which it refers. Here, Pierce is explaining that he believes the photograph cannot be separated fully from what it represents: in the same way as the words 'here' or 'there' within language, or like the fingerprint or bullet hole, the photograph is an indexical sign that is fundamentally linked to the physical

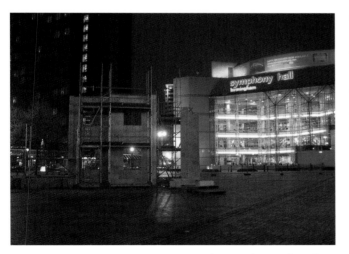

diesen Verständigungssystemen auf geradezu unorthodox unfotografische Weise.

Seine Fotografien beleuchten nicht den *Objekt*charakter des Baus, sondern vielmehr seine *Genese*. Sie geben dem unbewegten Bild als einem *aktiven* Dokument den Vorzug vor der *statischen* Dokumentation. In sämtlichen *house-projects* erzeugen spezialgefertigte Kameras unter Ausnutzung von analogen – also unmanipulierten – Technologien unbewegte und bewegte Bilder. Mit langen Belichtungszeiten wird jeder Bewegungsausschnitt auf dem Film fixiert.

Bei *house-madrid* erstreckte sich der Bau/Abbau über zehn Tage, wobei die Fotos unrealistischerweise brennende Straßenlaternen bei Tageslicht zeigen, während die Sonne auf der einen Seite hinter der Dächersilhouette untergeht und auf der anderen Seite über der Häuserzeile wieder aufgeht. Gerüstpfosten, die beim Bau zum Einsatz kamen, werden sichtbar, wo immer sie einige Zeit verweilen, und erwecken daher den Eindruck als seien sie in Bewegung. *House-projects* geht es nicht eigentlich um den Raum, sondern um die Zeit: Jede Konstruktion ist zwar auf ihren besonderen Aufstellungsort hin zugeschnitten, doch bildet dieser Ort lediglich eine Art Ankerplatz, der ahnen lässt, dass Weileders Pseudoarchitekturen überall stattfinden könnten. Die

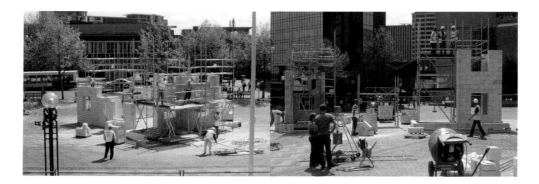

presence of what it is trying to signify or represent. So, at its simplest level, a photograph documenting one of Weileder's architectural events is implicitly connected to the event itself – that is the building and unbuilding of an architectural structure. But, his photographs subvert this. The image captures an extended instant, or a collection of instants, into a single image. Passing cars become pinpricks of light, people disappear, certain parts of the architectural structure are darker in colour that others, simply by dint of being more permanent. In this way the work addresses the notion that a photograph is understood in terms of what is not seen as much as what is seen. Weileder's photography becomes an active device that displaces the space between representation and object.

deskriptiven Fotografien haben ihre Punkt für Punkt genaue Entsprechung in der Natur, und doch kann das, was sie zeigen, nicht mit unbewaffnetem Auge gesehen werden. Eugène Atgets frühe Fotografien von Paris zeigten eine Stadt, die seltsam entvölkert schien. Nur hier und da erahnte man die geisterhafte Spur eines Menschen, der sich zu schnell bewegte, als dass die aus technischen Gründen notwendigen langen Belichtungszeiten ihn hätten an einen Ort bannen können. Auch Weileders Räume sind menschenleer, und doch fluten die Lichtpunkte von Scheinwerfern wie Staubkörnchen durch die Straßen. In den Darstellungen von Weileders Architektur variieren die unterschiedlichen Elemente in den Abschattierungen beträchtlich, da die Kamera Teile, die über einen längeren Zeitraum existieren, wie etwa die unteren Linien gemauerter Teile, mit kräftigeren

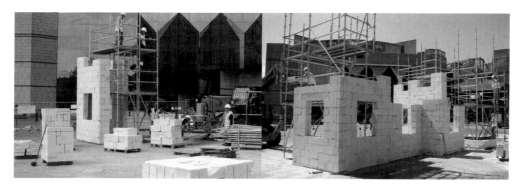

house-birmingham, 2004

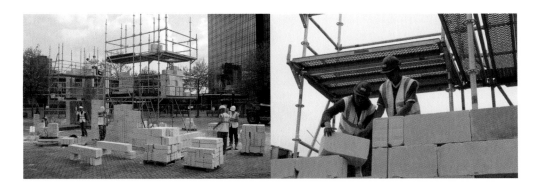

In *Notes on the Index* Krauss refers specifically to the work of Gordon Matta-Clark who, like Weileder, utilised photography and film as site for articulating interventions within architectural space. Describing Matta-Clark's work *Doors, Floors, Doors*[3], made for the opening of the New York exhibition space PSI in 1976, Krauss makes an argument that centres on the notion that the artist's work extended the indexical quality of the photograph into sculpture. Matta-Clark removed sections of the floor, and the mirrored space of the ceiling above, throughout the first, second and third floors. The vertical architectural structure was revealed, with the cuts made just in front of the doorway entrances so that on looking down, or indeed up, one could see the corresponding doorways on each of the floors. These interventions that existed within the fabric of the building

und schärferen Konturen ablichtet, dagegen die obersten Gerüstlagen abschattet, als seien sie mit dem Bleistift schraffiert. Eine der Hauptfunktionen der Fotografie liegt darin, Zeugnis abzulegen: ›Ich war dabei‹, einen unwiderlegbaren Beweis für ein Event zu liefern. Ein Foto zu verwenden, um auf Weileders inzwischen inexistente Interventions zu verweisen, verkompliziert die sich wandelnde Verhältnisbestimmung zwischen dem materiellen Träger und der Bedeutung eines Zeichens.

In ihrem Kapitel *Notes on the Index*, in dem es um Strömungen im Kunstschaffen der frühen 70er Jahre geht, führt Rosalind Krauss aus, wie Künstler sich ihres Erachtens mit den Indexsprachen der Fotografie im Bereich von bildhauerischen und interventionistischen Kunstpraktiken auseinandersetzen.[2] Sie beschreibt das Foto als ein System, das die Gegenwart von etwas, bedingt durch dessen Abwesenheit, unmittelbar wiedergibt. Das wiederum versetzt das Foto in die Lage, Äquivalent eines Objekts oder Events zu werden, die nicht mehr erfahrbar sind. Den Semiotiker Charles Sanders zitierend, schreibt Krauss: »Fotografien, vor allem unmittelbare Fotografien, sind sehr lehrreich, weil wir wissen, dass sie in vielfacher Hinsicht genau so sind wie die Objekte, die sie abbilden. Doch diese Ähnlichkeit verdankt sich der Tatsache, dass diese Fotografien unter Bedingungen entstanden sind, unter denen es physikalisch unmöglich wäre, nicht Punkt für Punkt mit dem, was sie abbilden, übereinzustimmen.« Das Foto stelle immer *etwas* dar, wobei die Definition dieses Etwas ganz und gar dem Event oder Objekt überlassen sei, auf das es sich beziehe. Es fungiere, semiotisch gesprochen, als sogenannter Shifter, als deiktisches Morphem. Pierce

were also transposed into photographs. Four images of the cuts were shown together, two rotated at ninety degrees anticlockwise and two at one hundred and eighty degrees. This creates a break between the visual representation and comprehension of what was being represented, with the definition of the work itself becoming difficult to articulate as there is a layering of elements constituting it. Like the photograph used for documentary purposes, *Doors, Floors, Doors*, requires what it is referring to – the removed sections of building – in order for it to make sense, but after the exhibition-event passed it comes to point to an absence, making the photograph not a stand-in or representation of the event but an intrinsic part of it.

Between 1972 and 1973 Matta-Clark made a series of works in the Bronx that directly engaged with how the fabric and occupation of the – at that time bankrupt – city responded to economic factors. Clandestinely sections were removed from floors and walls in a number of locations in the "ghetto areas of the Lower East Side and the Bronx, visiting buildings occupied primarily by packs of dogs and periodically by junkies"[4]. In the piece *Bronx Floors* (1972) the reference to the removed sections is complicated by the extracted pieces of architectural structure being shown alongside photographs of the structural cuts. In this work's initial exhibition at the artist-run space 112 Greene Workshop, the sections of removed buildings were exhibited alongside photographs of the voids in the building that had been created by the removal of the sections. Displayed standing vertically on the floor, or horizontally on trestle tables, these sculptural objects operated in the same way as the photographs – indexically referring to something that is

spricht hier von seiner Überzeugung, das Foto könne nicht gänzlich von dem, was es darstellt, losgelöst werden: Wie die Worte ›hier‹ und ›dort‹ im sprachlichen Bereich oder Fingerabdrücke bzw. Einschusslöcher in der Kriminalistik stelle das Foto ein Indexzeichen dar, das ganz wesentlich mit der körperlichen Gegenwart von dem verbunden ist, was es bezeichnen oder darstellen soll. Auf der einfachsten Ebene bedeutet dies, dass ein Foto, das eines der architektonischen Events Weileders dokumentiert, implizit mit dem Event selbst verbunden ist – also mit dem Auf- und Abbau eines architektonischen Gebildes. Weileders Fotos untergraben indes diese Funktion. Das Bild fängt einen gedehnten Moment oder eine ganze Reihe von Momenten in einem einzigen Bild ein. Vorüberfahrende Autos werden zu Nadelstichen aus Licht, Menschen verschwinden, bestimmte Teile des Gebildes sind farblich dunkler als andere, einfach wegen ihrer längeren Verweildauer. So gesehen vermittelt das Kunstwerk die Idee, das Foto sei nicht nur durch das definiert, *was es zeigt*, sondern mindestens ebenso sehr durch das, *was es nicht zeigt*. Weileders Fotografieren wird zu einem aktiven Kunstmittel, das den Raum zwischen Darstellung und Objekt auflöst.

In dem bereits erwähnten Kapitel *Notes on the Index* bezieht sich Krauss ausdrücklich auf das Werk von Gordon Matta-Clark, der wie Weileder Fotografie und Film als Ausdrucksmittel für Interventions in architektonischen Räumen verwendete. Bei der Beschreibung von Matta-Clarks Werk mit dem Titel *Doors, Floors,*

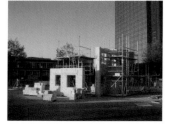
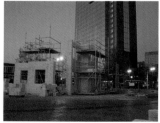

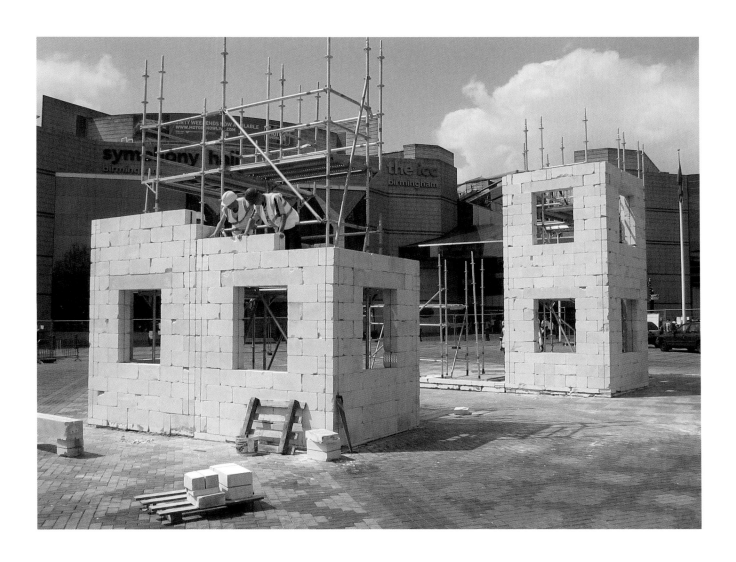

house-birmingham, 2004

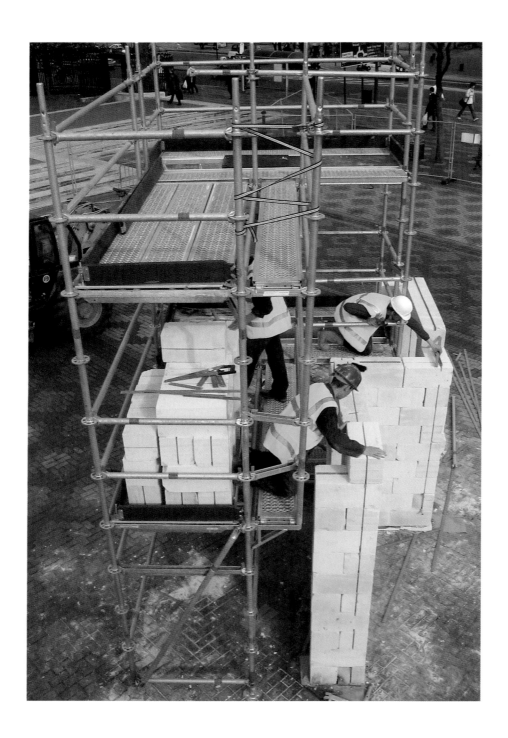

house-birmingham, 2004

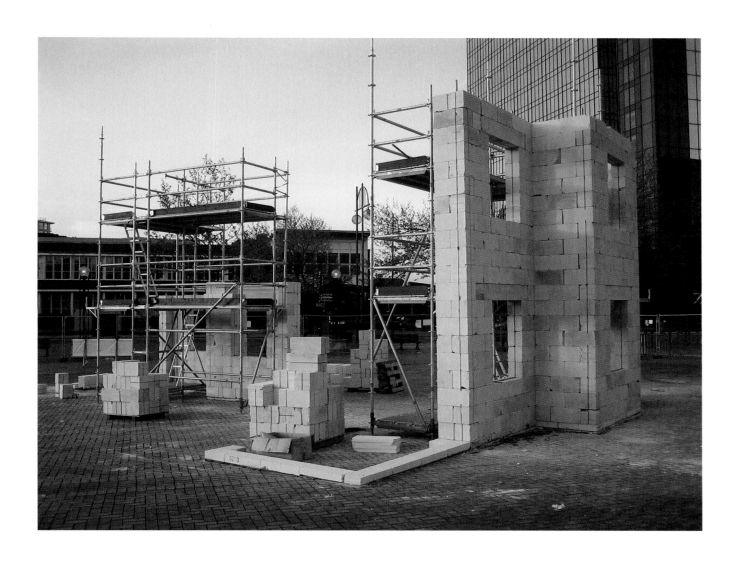

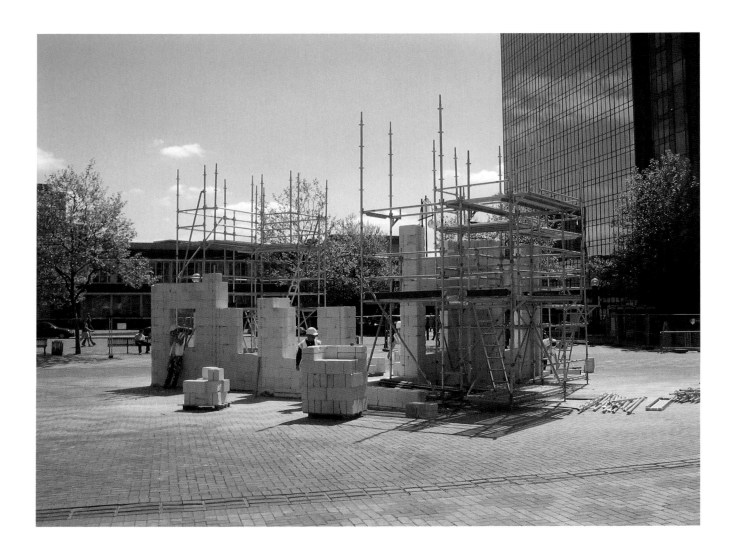

house-birmingham, 2004

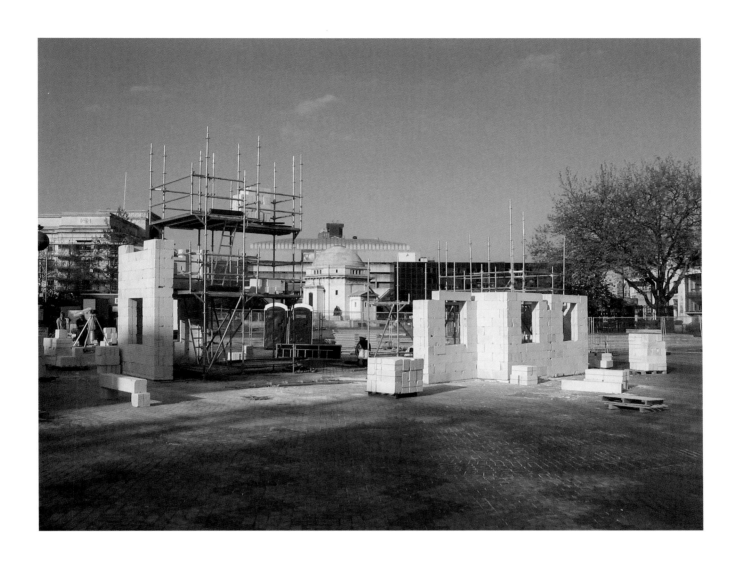

not present. The objects indicate a building where an absence has been created, a missing element that is in fact present in the very gallery space. A circular process of reference and referent are created. One cannot see the removed floor without being aware of what was there before. Krauss regards Matta-Clark as using the photograph as a conceptual model for his three dimensional work, describing how in *Doors, Floors, Doors* the building is "physically present but temporally remote [...] In the piece by Matta-Clark the cut is able to signify the building – to point to it – only through a process of removal or cutting away. The procedure of excavation succeeds therefore in bringing the building into the consciousness of the viewer in the form of a ghost"[5]. With historical distance, this use of photog-

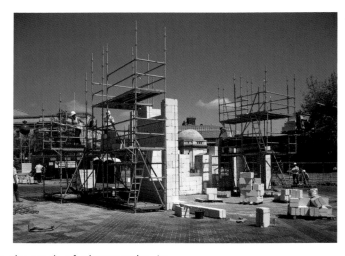

raphy as a model is extended, redoubling the importance in the work of photography. In both *Doors Through and Through* and *Bronx Floors*, it is necessary to look at the photograph-as-documentation in order to make sense of the photo work. Both uses of photography refer to each other.

In both Weileder's and Matta-Clark's work the impossibility of being able to see for oneself the physical element of the work brings in the dimension of time as a key medium in both practices,

Doors, das zur Eröffnung der Ausstellungsräume des PSI in New York im Jahre 1976 fertig gestellt wurde,[3] argumentiert Krauss, das Werk des Künstlers übertrage die Indexqualität des Fotos auch auf Skulpturen. Matta-Clark hatte damals Teile des Fussbodens und die dazu spiegelbildlichen Areale der Decke in der ersten, zweiten und dritten Etage entfernt. Auf diese Weise war die Vertikale im architektonischen Gefüge zum Vorschein gekommen, wobei die Cuts unmittelbar vor den Türschwellen gesetzt worden waren, so dass man beim Hinauf- oder Hinunterschauen die entsprechenden Türen in jedem Stockwerk sehen konnte. Diese Intervention in die Bausubstanz wurde auch in Fotos umgesetzt. Vier Cut-Bilder wurden gemeinsam gezeigt, zwei davon um 90 Grad gegen den Uhrzeigersinn gedreht, die beiden anderen um 180 Grad. Dies führt zu einem Bruch zwischen der visuellen Repräsentation und dem Wissen um das, was repräsentiert wurde. Das erschwert auch die Definition des Werkes selbst, da es ein aus verschiedenen Elementen komponiertes Schichtwerk ist. Wie das für Dokumentationszwecke genutzte Foto bedarf auch *Doors , Floors, Doors* dessen, worauf es sich bezieht, nämlich auf die entfernten Partien eines Gebäudes, um einen Sinn zu ergeben. Doch nach dem Ende des Ausstellungs-Events verweist das Foto auf ein Abwesendes. Es steht nicht mehr nur ersatzweise und stellvertretend für ein Event, sondern wird zu seinem integralen Bestandteil.

Zwischen 1972 und 1973 schuf Matta-Clark in den Bronx eine Serie von Werken, in denen er sich mit der Frage auseinandersetzte, wie sich wirtschaftliche Faktoren auf Substanz und Besitzverhältnisse der – damals bankrotten Stadt – auswirkten. Heimlich entfernte er Fußboden- und

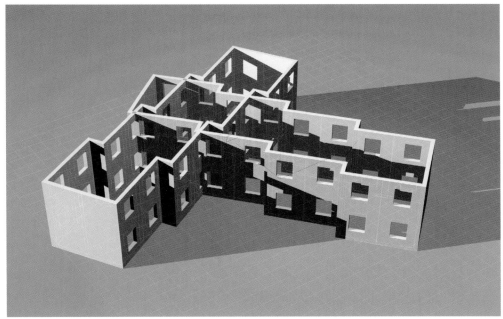

house-birmingham, 2004
Computer generated
proposal sequence

with photograph itself evolving over time as it passes into history. The photograph neither legitimises the event, nor the event the photograph; produced neither as simply an aesthetic object nor 'mere documentation' process is paramount. In this way the work insists on the viewer thinking between modes of representation and perception.

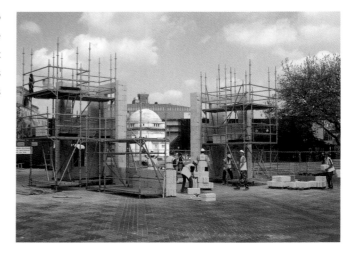

Wandteile an mehreren Orten in den »Ghettobezirken der Lower East Side und in den Bronx, Absteigen, die vornehmlich von streunenden Hunden und gelegentlich von Junkies genutzt wurden«[4]. In dem Stück *Bronx Floors* (1972) wird der Bezug zu den entfernten Teilen dadurch erschwert, dass die aus dem architektonischen Baukörper herausgeschnittenen Stücke Seite an Seite mit den Fotos von den Bauschnitten gezeigt werden. Bei der ersten Ausstellung dieses Werkes im 112 Greene Street Workshop wurden die Gebäudeausschnitte neben Fotos von den so geschaffenen Lücken in den betreffenden Gebäuden gezeigt. Vertikal auf dem Boden stehend oder horizontal auf Tischen, die durch Böcke gestützt wurden, arrangiert, entfalteten diese bildhauerischen Objekte dieselbe Wirkung wie die Fotos: sie verwiesen als Indexzeichen auf etwas, das abwesend war. Die Objekte zeigen ein Gebäude, in dem eine Absenz geschaffen wurde, ein Element fehlt, das jedoch in dem Galerieraum zur gegebenen Zeit anwesend ist. So entsteht ein zirkulärer Prozess von Referenz und Referent (Denotat). Der Betrachter erkennt die Stücke des Fußbodens und »sieht« dabei immer auch den Rest. Krauss glaubt, Matta-Clark setze die Fotografie als ein konzeptuelles Modell für seine dreidimensionalen Arbeiten ein, und beschreibt, wie in *Doors, Floors, Doors* das Gebäude »physisch gegenwärtig, aber vorübergehend fern ist [...] In dem Stück von Matta-Clark wird das Gebäude in dem Cut nur durch einen Prozess der Entfernung oder des Wegschneidens gekennzeichnet. Die Prozedur des Ausschneidens schafft es, dem Betrachter das Gebäude in Form eines Geistes ins Bewusstsein zu heben.«[5] Rückblickend hat dieser Gebrauch von Fotografie als Modell Schule gemacht, wodurch der fotografische Teil des Werks

house-birmingham, 2004
Computer generated
proposal sequence (detail)

house-birmingham, 2004

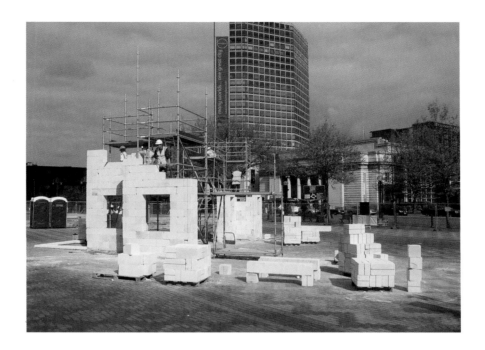

an Bedeutung enorm gewonnen hat. Sowohl im Falle von *Doors Through and Through* als auch von *Bronx Floors* ist es unerlässlich, das Foto als Dokumentation zu betrachten, um die Foto-arbeiten würdigen und verstehen zu können. Beide Verwendungen der Fotografie beziehen sich aufeinander.

In Weileders wie Matta-Clarks Werk wird als Schlüsselmedium die Zeitdimension eingebracht, da es ansonsten unmöglich wäre, das Werk als physisches Gebilde zu erfahren, wobei sich das Foto selbst entwickelt, indem es zur Geschichte wird. Das Foto legitimiert nicht das Event, und das Event legitimiert nicht das Foto; weder ästhetische Objekt-Kreation noch ›schiere Dokumentation‹, steht das Foto in erster Linie für den Prozess. Auf diese Weise zwingt das Werk den Betrachter, Darstellungs- und Wahrnehmungsformen gleichermaßen zu bedenken.

1 Sanford Kwinter, *Physical Theory and Modernity*, in *Architectures of Time*, MIT Press 2001.

2 Rosalind E Krauss, *Notes on the Index*, pp. 196–219, in *The Originality of the Avant-Garde and Other Modernist Myths*, MIT Press, 1985.

3 Also known as *Doors Through and Through*, 1976. Series of cuts for the exhibition *Room PS1* at PS1, New York. Cuts, black and white documentary photographs and colour photowork.

4 Interview with Gordon Matta-Clark in *Matta Clark*, Internationaal Cultureel Centrum Antwerp, 1977, p. 8.

5 Rosalind E Krauss, *Notes on the Index*, p. 217, in *The Originality of the Avant-Garde and Other Modernist Myths*, MIT Press, 1985.

LISA LE FEUVRE is a curator and writer. She is Associate Lecturer on the MA Curating at Goldsmiths College and is Curator of Contemporary Art at the National Maritime Museum. Her recent exhibitions include *Avalanche 1970–1976* (Chelsea Space, London, 2005), Simon Faithfull/*ceblink* (Stills, Edinburgh and Cell, London 2006) and *Dennis Oppenheim: Recall* (MOT, London, 2006).

1 Sanford Kwinter, *Architectures of Time*, Cambridge, Mass.: MIT Press 2001 im Kapitel ›Physical Theory and Modernity‹.

2 Rosalind E. Krauss, *The Originality of the Avant-Garde and Other Modernist Myths*, Cambridge, Mass.: MIT Press 1985, S. 196–219.

3 Auch bekannt unter dem Werktitel *Doors Through and Through*, 1976. Serie von Cuts für die Ausstellung *Room PSI* am PSI, New York. Cuts, Dokumentationsfotos in schwarz weiß sowie farbige Fotoarbeiten.

4 Interview mit Gordon Matta Clark, Internationaal Cultureel Centrum Antwerp, 1977, S. 8.

5 Rosalind E. Krauss, The Originality of the Avant-Garde and Other Modernist Myths, Cambridge, Mass.: MIT Press 1985, S. 217.

LISA LE FEUVRE ist Kuratorin und Schriftstellerin. Sie lehrt im Rahmen des Magisterstudiengangs Museumswissenschaften am Goldsmiths College und arbeitet als Kuratorin für zeitgenössische Kunst im National Maritime Museum in London. Zu ihren jüngsten Ausstellungen gehören: *Avalanche 1970–1976* (Chelsea Space in London, 2005), Simon Faithfull/*ceblink* (Stills in Edinburgh und Cell in London, 2006) und *Dennis Oppenheim: Recall* (MOT Galerie in London, 2006).

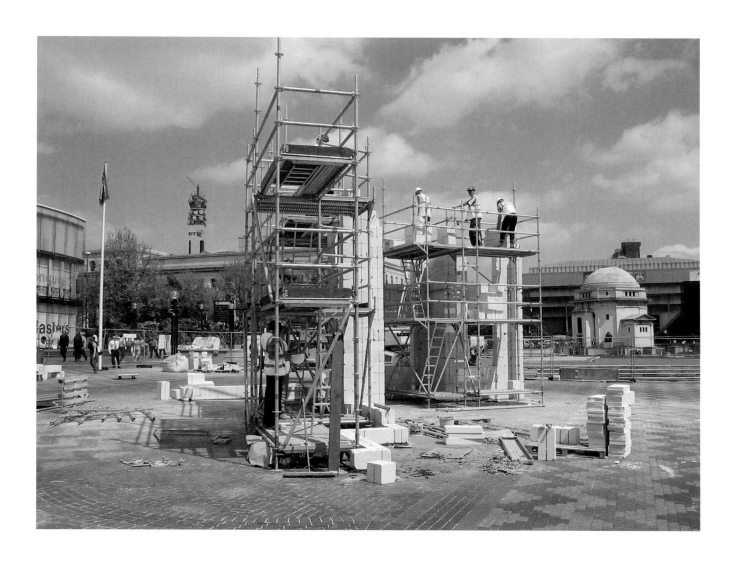

house-birmingham, 2004

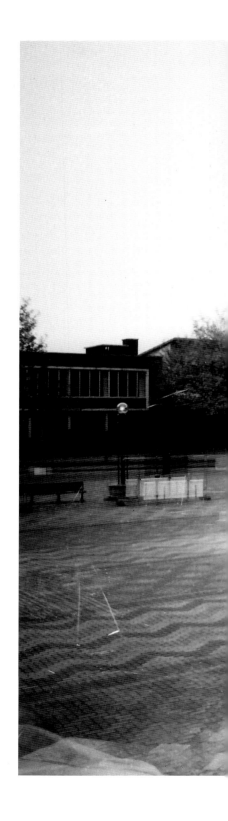

house-birmingham_2, 2004
Gelatin silver print
79 x 100 cm

100

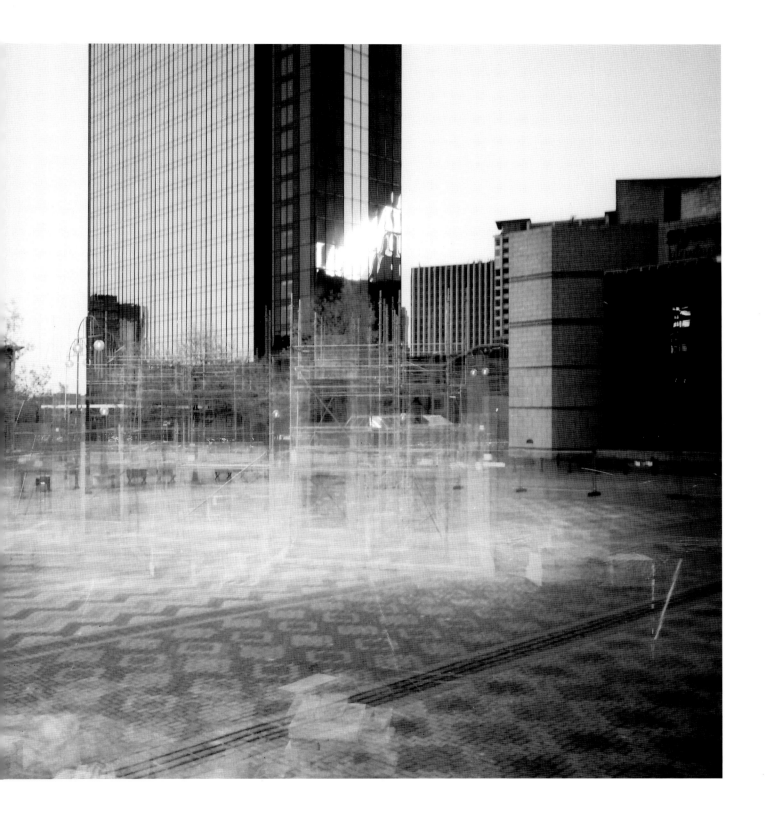

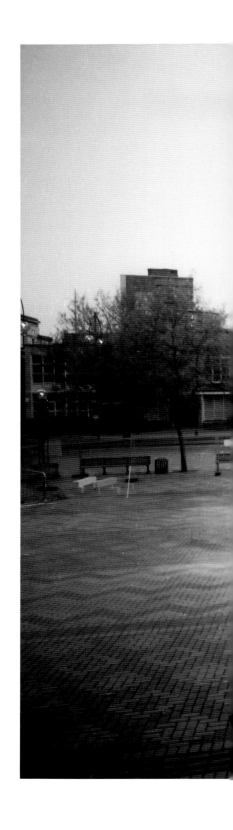

house-birmingham_1, 2004
Gelatin silver print
79 x 100 cm

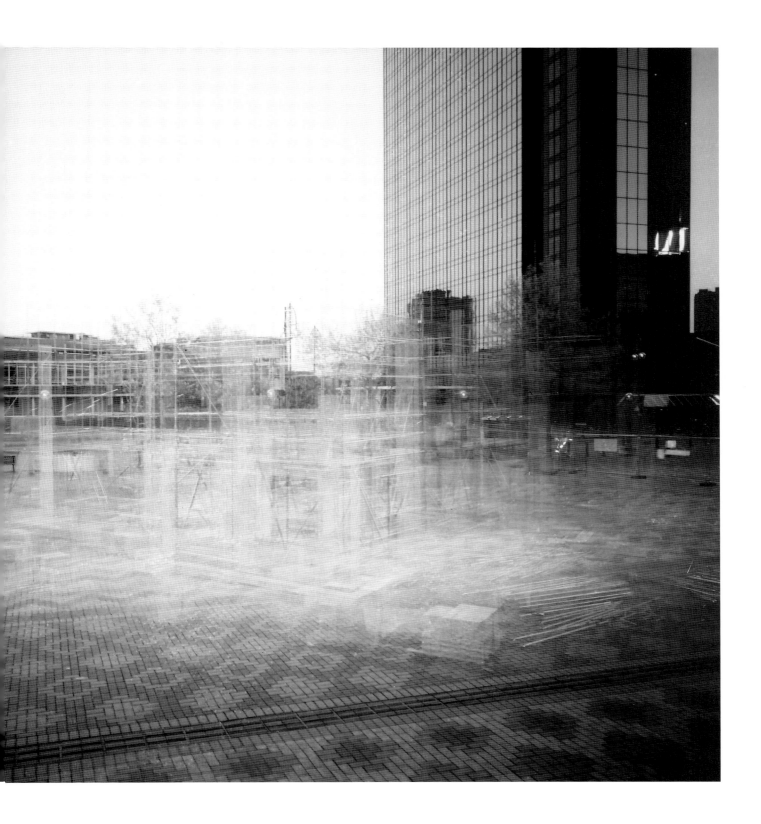

BIOGRAPHY

Born 1965, Munich

Education
1995–1996
School of Visual Arts, New York
1989–1995
Academy of Fine Arts, Munich

Solo Exhibitions / Projects

2005
house-birmingham (Film)
IKON Gallery, Birmingham

2004
house-birmingham
IKON Gallery, Birmingham*
house-madrid
Madrid Abierto, Plaza de Colón

2003
house-city
Grainger Town, Newcastle
barriers + dinghies
Forth Banks, Newcastle*

2002
muraiki
(with Matthew Sansom)
t-u-b-e Galerie für radiophone
Kunst, Munich; Globe Gallery,
North Shields, England*

2000
jam
Ausstellungsforum FOE 156,
Munich

1996
*Sie zeigten, daß ein Computer
einfacher zu steuern war, wenn
man Dinge auf dem Bildschirm
zeigen und Bilder sehen konnte.*
(with Daniel Tharau)
Arena, Berlin

1996
CHECKMATE
(with Daniel Tharau)
SVA Amphitheater, New York

1994
Wolfgang Weileder
Kunstforum, Städtische Galerie
im Lenbachaus, Munich

1992
BOAT
Hatton Gallery, Newcastle

Selected Group Exhibitions
(since 1995)

2005
Interfilm 2005, Berlin
*Rencontres Internationales Paris/
Berlin 2005*, Paris
Impakt Festival 2005, Utrecht

2004
Madrid Abierto 2004, Madrid

2003
ARENA
Samling Foundation; Baltic Centre
for Contemporary Art, Gateshead

2002
connecting principle, University
of Newcastle, Newcastle
land+the Samling, Samling
Foundation; Sculpture Park
at Kielder Reservoir,
Northumberland*

2001
*CERAMICS, Form and Fantasy
in European Sculpture*,
E.P.O. Europäisches Patentamt
and Rathausgalerie, Munich*

2001
Werkstattpreis 1997–2001
Kunststiftung Erich Hauser,
Rottweil

2000
Was geschied bestimmt der Ort
L.A.C. Lieu d'art Contemporain,
Sigean, France*
Staatliche Förderungspreise 1999
Galerie der Künstler, Munich*

1999
x-mas
Kent Gallery, New York

1998
Werkstattpreis 1998
Kunststiftung Erich Hauser,
Rottweil*

1997
*Zehnte Ausstellung der Jürgen
Ponto-Stiftung 1997*
Kunstverein, Frankfurt*

1996
SPECIFICS
SVA Gallery, New York
*Junge Kunst 1996, Saar Ferngas
Förderpreis*
Wilhelm-Hack-Museum,
Ludwigshafen*
Out of Egypt
Ägyptische Staatssammlung,
Munich*

1995
Debütanten 1995
Academy of Fine Arts, Munich*
Ortung
GSF-Forschungszentrum für
Umwelt und Gesundheit, Munich*

* Denotes publication

Awards / Grants

2005
New Partners Award
Arts & Business, England

AHRC Research Award
Arts & Humanities Research
Council, UK

2004
Grants for the Arts
Arts Council England

2003
ARENA
Samling Foundation and NESTA

2000
USA-Stipendium
Bayerisches Staatsministerium
für Wissenschaft, Forschung
und Kunst, Munich

1999
*Förderungspreis für Bildende
Kunst des Freistaats Bayern*
Bayerisches Staatsministerium
für Wissenschaft, Forschung
und Kunst, Munich

1998
Werkstattpreis 1998
Kunststiftung Erich Hauser, Rottweil

1995–1996
USA-Stipendium
Deutscher Akademischer
Austauschdienst (DAAD)

1995
Debütantenpreis 1995
Bayerisches Staatsministerium
für Wissenschaft, Forschung
und Kunst, Munich

1991–92
Auslandsstipendium England
Studienstiftung des Deutschen Volkes

1991–1995
Stipendium der Studienstiftung
des Deutschen Volkes

BIBLIOGRAPHY

Solo Catalogues / Publications

2003
docking, barriers + dinghies,
Blue River, Newcastle
Text by David Butler

2002
Muraiki
(audio CD, with Matthew Sansom)
t-u-b-e Galerie für radiophone
Kunst, Munich;
Globe Gallery, North Shields,
England

1995
Wolfgang Weileder,
Debütanten 1995
Bayerisches Staatsministerium
für Wissenschaft, Forschung
und Kunst, Munich
Text by Susanne Gänsheimer

Group Catalogues / Publications

2005
From Audéoud to Zhao Bandi,
selected Ikon Off-site Projects
2002–2004
IKON Gallery, Birmingham
Text by Helen Legg

2002
land + the Samling
Samling Foundation and
Sculpture Park at Kielder
Reservoir, Northumberland
Text by David Butler

2001
CERAMICS, Form and Fantasy
in European Sculpture
E.P.O. Europäisches Patentamt
and Rathausgalerie, Munich
Text by Susanne Gänsheimer

2000
Was geschied bestimmt der Ort
L.A.C. Lieu d'art Contemporain,
Sigean, France
Text by Wolf Dieter Enkelmann

1999
Förderungspreise für
Bildende Kunst 1999
Bayerisches Staatsministerium
für Wissenschaft, Forschung
und Kunst, Munich

1998
Werkstattpreis 1998
Kunststiftung Erich Hauser, Rottweil
Text by Ursula Zeller

1996
Out of Egypt
Ägyptische Staatssammlung,
Munich
Text by Silvia Schoske

1995
Ortung
GSF-Forschungszentrum für
Umwelt und Gesundheit,
Munich
Text by Willi Stahlhofen

1994
Kunststudenten stellen aus
Kunsthalle der Bundesrepublik
Deutschland, Bonn

Anvisiert
Deutsches Museum, Munich/
Oberschleissheim
Text by Heinz Schütz

1993
Kunstflug
Deutsches Museum, Munich/
Oberschleissheim
Text by Andrea Lucas

1992
JETZT
Künstlerwerkstätten Lothringer
Strasse 13, Munich
Text by Jutta Tezmen-Siegel

house
Connecting Principle,
University of Newcastle
16–17 October 2002
Curated by Monica Ross

house-city
ARENA, Samling Foundation
and BALTIC Centre for
Contemporary Art, Gateshead
14–17 July 2003, Grainger Town

house-madrid
Madrid Abierto 2004, Madrid
5–5 February 2004
Paseo de Recoletos
Curated by Jorge Díez Acón

house-birmingham
Ikon Gallery, Birmingham
10–21 May 2004
Centenary Square
Curated by Nigel Prince

house was supported by
Newcastle College
The Arts and Humanities
Research Fund of the University
of Newcastle
The School of Arts and Cultures,
University of Newcastle

Special thanks to
James Anderson, Paul Armstrong,
William Barstow, Lee Baynham,
Colin Bickerstaff, Joseph Bolam,
Matt Brack, Divya Cherian,
Clive Dixon, Ray Dixon, Jeremy
Fay, Alison Gibb, Rachel Gibbs,
Sarah Good, David Graham,
Jenny Guariento, Hannah Kirkham,
Poppy Leather, Edwin Li, Debbie
Lyon, Ant Macari, Sean Mallen,
Hannah Marsden, Phil Marsden,
Jenny Mathers, Helen Moore,
Michael Murray, Jimmy Norris,
Sarah J Oates, Mark Pembrey,
Monica Ross, Jonathan Scott,
Sunghoon Son, Gavin Tipping,
William Richmond-Watson
and everybody else involved in
house.

house-city was supported by
The Samling Foundation
BALTIC Centre for Contemporary
Art, Gateshead
NESTA (National Endowment for
Science, Technology and the Arts)
Northern Rock Foundation
Aimhigher
R.Bau, Sunderland
Thermalite
Interserve
Lovell
Newcastle College
The School of Arts and Cultures,
University of Newcastle
The City of Newcastle

Special thanks to
Valentin Albersmann, Paul Arm-
strong, Lee Baynham, André Böhm,
Joseph Bolam, Michael Bostock,
Richard Broderick, Andrew Bryce,
Ben Burns, Emily Charlton, Paul
Colbert, Eddie Connelly, Clive
Dixon, Ray Dixon, Alan Findley,
Tony Fox, Tony Gallon, Antony
Gormley, Tony Gradwell,
Timandra Gustafson, Alistair
Hampson, Cheryl Hargreaves,
Victoria Jones, Roger McKechnie,
Kudith King, Samantha Lennox,
Denis Lockey, Graham Murray,
Michael Murray, Jimmy Norris,
Adam Pickard, Jenny Reid, Rob
Reid, Julie Renwick, Paul Reynolds,
Philippa Rickard, Aaron Robson,
Janet Ross, Paul Rubinstein,
Colin Stott, Rob Scott, Naomi
Shedden, Emma Thomas, Steven
Todd, Steve Walton, Paul Webster,
Neil Weeks, David Whitmore,
Katie Wood, Karon Wright,
Edaloida Zela and everybody else
involved in *house-city*.

house-madrid was supported by
Madrid Abierto 2004
Fundación Altadis
Comunidad de Madrid
Fundación Madrid Nuevo Siglio
Fundación Canal
The Arts Council, England
Eurobloque
R.Bau, Sunderland
The City of Sunderland
ETEC, Sunderland
The Fundacion Laboral de la
Construcción, Madrid
Olivella I Fills S.L.
Telefonica
The School of Arts and Cultures,
University of Newcastle

Special thanks to
Jorge Díez Acón and his team,
Ryan Brown, Liam Cowie,
Paul Colbert, Edward Ellis,
Steven Hawkes, Denis Heaney,
Kirsten Hilling, Peter Humble,
Christopher Newby, Bjert Olsson,
Tom Robinson, Christopher
Rooney, Neil Smith, Martin Spoors,
Steven Todd, Paul Webster,
Chris Whelan, Ronald van Zijl,
all the volunteers from the
Fundacion Laboral de la Construc-
ción, Madrid, the staff from
the Telefonica shop nearby and
everybody else involved in
house-madrid.

house-birmingham was supported by
IKON Gallery
The Arts Council, England
The City of Birmingham
Eurobloque
R.Bau, Sunderland
Layher
Acorn Scaffolding
CITB National Construction College
South Birmingham College
Intracamion, Munich
The School of Arts and Cultures,
University of Newcastle

Special thanks to
Erin Angove, Shaun Catterall,
Terry Carver, Mahendra Chauhan,
Bill Clarke, Paul Colbert, Kieran
Conway, Brendan Dove, Kieran
Dove, Geoff Gower, Wolfgang
Flössler, Michael, Trevor Ford,
Mark Franks, Kirsten Hilling,
Debbie Kermode, Wasim Khan,
Tony McCrow, Lee Neale,
Charlotte Levine, Robert Norris,
Andrew Nutter, Damien O'Donnell,
Bjert Olsson, Terry Prayne, Nigel
Prince, Francis Quinn, Matthew
Sansom, Dennis Scott, Liam Smith,
Lee Stowers, Richard Sutton,
David Temple, Steve Todd,
Tony and Scooby, Agathi Tsoroni,
Sophie Ward, Chris Whelan,
Chloe Watkins, Jonathan Watkins,
Paul Webster, David Whitmore,
Ian Wilson, Steve Woodfield,
Ronald van Zijl, all the staff from
IKON Gallery and everybody
else involved in *house-birmingham*.

Wolfgang Weileder
house-projects
Ikon Gallery 2005

http://www.house-projects.com

ISBN 1 904864 18 X

Ikon Gallery
1 Oozells Square, Brindleyplace,
Birmingham, B1 2HS
t: +44 (0) 121 248 0708
f: +44 (0) 121 248 0709
http://www.ikon-gallery.co.uk
Registered charity no: 528892

Edited by Florian Matzner
and Nigel Prince
Designed by kruse², Munich
Printed by Jütte Messedruck
Leipzig GmbH, Leipzig

Photography
David Jimenez, Madrid:
Cover, Page 65, 77
Gary Kirkham, Birmingham:
Page 86 (top left), 87 (left), 94
Bjert Olsson, Alicante:
Page 70 (left), 72
All others by the artist

Distributed by Cornerhouse
Publications

70 Oxford Street, Manchester,
M1 5NH
publications@cornerhouse.org
t: +44 (0)161 200 1503
f: +44 (0)161 200 1504

Ikon Staff

Visitor Assistants
Arsha Arshad
Simon Bloor

Assistant – Ikon Shop
Mike Buckle

Education Coordinator
James Cangiano

PA/Office Manager
Rosalind Case

Fundraising Manager
James Eaves

Programme Assistant
Siân Evans

Manager – Ikon Shop
Richard George

Deputy Director
Graham Halstead

Facilities Technician (AV/IT)
Matthew Hogan

Curator (Education and Interpretation)
Saira Holmes

Curators (Off-site)
Deborah Kermode
Helen Legg

Marketing Assistant
Emily Luxford

Facilities Technician
Chris Maggs

Visitor Assistants
Deborah Manning
Jacklyn McDonald
Natalia Morris
Michelle Munn

*Education Coordinator
(Creative Partnerships)*
Esther Nightingale

Gallery Facilities Manager
Matt Nightingale

Marketing Manager
Melissa Nisbett

PR and Press Manager
Jigisha Patel

Curator (Gallery)
Nigel Prince

Gallery Assistant
Theresa Radcliffe

Gallery Assistant
Kate Self

Education Coordinator
Nikki Shaw

Technical and Office Assistant
Richard Short

Exhibitions Coordinator
Diana Stevenson

Finance Manager
Dianne Tanner

Director
Jonathan Watkins

Visitor Assistant
Leon Yearwood

Ikon gratefully acknowledges financial assistance from Arts Council England, West Midlands and Birmingham City Council. The publication was supported by a grant from Arts & Business and R.Bau Sunderland.

Cover illustration
house-madrid, 2004 (detail)

Endpapers
house-madrid_1, 2004 (detail)
Gelatin silver print
79 x 100 cm

Acknowledgements

The artist would like to thank
Nigel Prince
Florian Matzner
Jonathan Watkins
Lisa Le Feuvre
Sven-Olov Wallenstein
Saskia Helena Kruse
Leonie von Reppert-Bismarck
Thomas Rütten
Antony Gormley
Gabriele Heller
Clemens, Marlies and Veronica

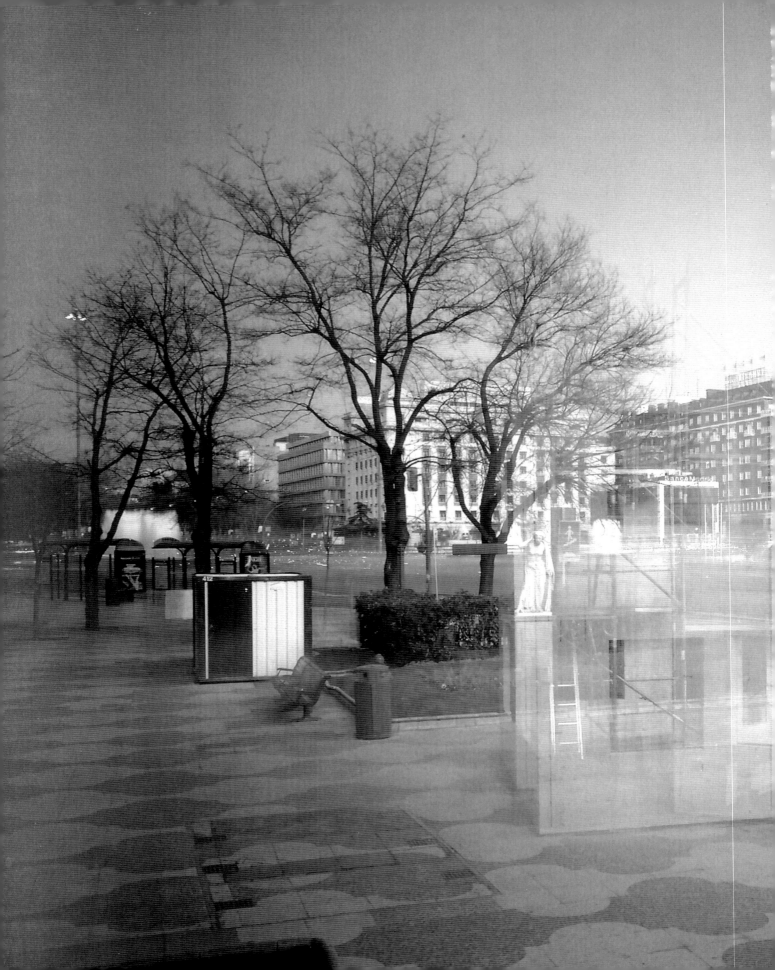